Beasts

THE MEDIEVAL IMAGINATION

Beasts

FACTUAL & FANTASTIC

ELIZABETH MORRISON

THE J. PAUL GETTY MUSEUM
THE BRITISH LIBRARY

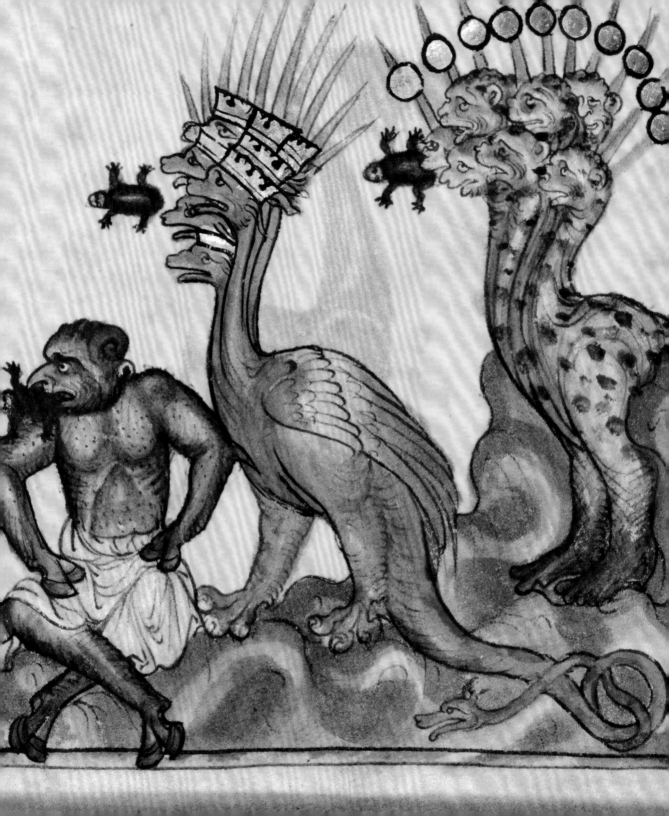

© 2007 J. Paul Getty Trust
Third printing

Published by the J. Paul Getty Museum, Los Angeles
Getty Publications
1200 Getty Center Drive, Suite 500
Los Angeles, California 90049-1682
www.getty.edu/publications

Patrick E. Pardo, *Editor*
Kurt Hauser, *Designer*
Amita Molloy, *Production*

Distributed in the United States and Canada by the
University of Chicago Press

Distributed outside the United States and Canada by
Yale University Press, London

Printed in Malaysia

Library of Congress Cataloging-in-Publication Data
Morrison, Elizabeth, 1968–
 Beasts factual and fantastic / Elizabeth Morrison.
 p. cm. — (Medieval imagination)
 ISBN 978-0-89236-888-4 (hardcover)
1. Animals in art. 2. Animals, Mythical, in art. 3. Illumination of books
and manuscripts, Medieval. I. Title. II. Series.
 ND3339.M67 2007
 751.4'26—dc22

 2006037780

Front cover: Detail of *A Dragon* (fig. 72)
Back cover: Detail of *The Creation* (fig. 2)
Frontispiece: Detail of *Unclean Spirits Issuing from the Mouths of the Dragon, the Beast, and the False Prophet* (fig. 83)

Sources for Quotations

Page viii: Text and translation provided by The Aberdeen Bestiary Project, *www.abdn.ac.uk/bestiary/*, fol. 7.

Page 4: Bible (New American Standard Version).

Pages 33–35: Author's own translation into English, based on the French of Marcel Thomas in Gaston Phébus, *Le Livre de la Chasse* (Philippe Lebaud, Éditeur, Paris, 1986): 54, 61, 71, 90–91, 106, 163.

Page 36: Thomas of Chobham, *Summa de arte praedicanti*, chap. 7; translated by D. L. d'Avray, *The Preaching of the Friars: Sermons Diffused from Paris before 1330* (Oxford, 1985): 232–33; quoted in Debra Hassig, *Medieval Bestiaries: Text, Image, Ideology* (Cambridge University Press, 1995): xv.

Pages 64–67: Text and translation provided by The Aberdeen Bestiary Project, *www.abdn.ac.uk/bestiary/*: Eagle, fol. 61; Lions, fols. 7–7v; Beaver, fol. 11; Crocodile and Hyrdus, fol. 69. Text and translation provided by T. H. White, *The Book of Beasts* (G.P. Putnam's Sons, New York, 1954): Monkey, 34; Sea Creature, 197–98.

Page 68: Bernard of Clairvaux, *Apologia ad Guilelmum*; translation by Michael Casey in *Cistercians and Cluniacs: St. Bernard's "Apologia" to Abbot William* (Cistercian Publications, Kalamazoo, Michigan, 1970): 66.

Pages 99–101: Bible (NASV).

Copyright of the illustrations is indicated in the captions by the initials JPGM (J. Paul Getty Museum) and BL (British Library).

Author's Acknowledgments
Special thanks are due to Thomas Kren, Jessica Berenbeim, Peter Kidd, Brian Stokes, the Lyden family, and Ingrid and Amsel, who can be considered fantastic creatures themselves for helping me with this book.

CONTENTS

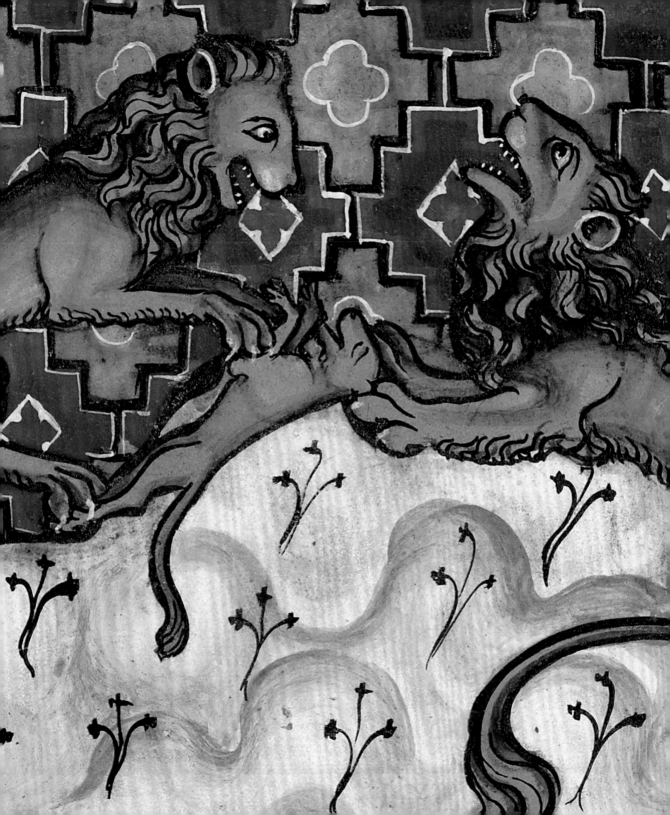

FOREWORD

A few years ago, Kurt Hauser, who has designed many beautiful publications for the J. Paul Getty Museum's Manuscripts Department over the years, put forward an idea for a new series of books that would introduce the Getty Museum's manuscripts collection to a broader audience. The resulting series, called the Medieval Imagination, intends to reveal to the reader medieval conceptions of the world and their expression in art. Elizabeth Morrison, Associate Curator of Manuscripts at the Getty Museum, assumes the editorship of the series with this inaugural volume, of which she is also the author. In addition to establishing a high standard of writing in these pages, she has lined up a splendid list of titles, each by a different expert, to appear in coming years. The British Library also encouraged the author to draw upon its extraordinary manuscripts collection, and the two institutions are pleased to collaborate on this first volume.

Beasts Factual and Fantastic is a delightful beginning for the series because animals, both real and fanciful, were such an important part of medieval culture. Animals played an integral role in daily life and thought, and their depiction in manuscripts offers insights into both human nature and the medieval imagination.

We would like to thank Rebecca Vera-Martinez, Michael Smith, and Rose Rachal for the superb photography of works from the Getty's collection and the photographers at the British Library for additional photography of manuscripts from its collection. Kurt Hauser, naturally, provided the elegant design of these pages. We are also grateful to Mark Greenberg, Patrick Pardo, Amita Molloy, Leslie Rollins, Deenie Yudell, Karen Schmidt, and Rob Flynn at Getty Publications and David Way, Kathleen Houghton, and Lara Speicher at the British Library for their contributions to the realization of this volume and to the Medieval Imagination series.

Thomas Kren
Curator of Manuscripts
The J. Paul Getty Museum

Scot McKendrick
Head of Western Manuscripts
The British Library

Here begins the book of the nature of beasts.
Of lions, panthers and tigers, wolves and foxes, dogs and apes

FROM A THIRTEENTH-CENTURY BESTIARY

INTRODUCTION

Dogs pursue their prey along the pages of hunting treatises, newly created animals described in Genesis emerge from the leaves of Bibles, creatures representing the signs of the zodiac stretch across the night sky in astrological texts, and whimsical beasts—part human, part animal—peer around the corners of painted letters in every type of book imaginable. Animal life positively abounds in medieval manuscripts. While animals still play an active role in our own contemporary visual culture—from the singing woodland creatures of Walt Disney movies to the animal mascots of professional sports teams—the depiction of animals in the medieval era is perhaps unequaled in the history of Western art. Medieval tapestries, sculpture, and even metalwork display numerous animals in abundance, but it is in the colorful pages of illuminated manuscripts that beasts hold the greatest sway, brought to life by some of the most skilled artists of the time.

One reason for the proliferation of creatures in medieval books is that animals played such a dominant role in everyday life. In the Middle Ages, animals formed the backbone of daily life in a primarily farm-based economy. They provided meat and dairy products, supplied wool and leather for clothing and shoes, contributed the brute strength needed to till the land, were the sole means of rapid travel, and even afforded the resources necessary for the creation of books—from bird-quill pens to the animal-skin parchment used as the primary writing surface throughout the Middle Ages. It was natural, then, that the art of the period would reflect activities involving animals, including the yearly cycle of farming duties, elaborate hunts that were a source of both food and entertainment for the nobility, and the violent clashes between horse-mounted soldiers in an era of frequent war.

Daily contact with animals was almost unavoidable in the Middle Ages, but the fascination with animals evidenced by the art of the period was also partly due to the Christian belief system that permeated medieval culture. According to Christian theology in the Middle Ages, God had created the creatures not only to be useful to man in providing provisions and companionship but also as symbols of the divine plan that was inherent in every aspect of the natural world. The most common symbols for Christ in the period were a lamb or a lion, while saints were often helped by kindly animal friends or tested in their faith by demonic beasts. Even in secular life, however, animals were widely held to embody standard characteristics that reflected symbolic values. Loyal dogs or formidable lions were incorporated into the coats of arms of the aristocracy to indicate nobility, and the constellations in the night sky, such as Taurus, Leo, and Aries, were believed to influence the fates of individual men as well as entire nations. Symbolic animals crept into every aspect of manuscript illumination, from full-page miniatures of biblical tales involving animals to lively drawings of animal fables inherited from Greek and Roman times.

The creatures medieval people encountered in daily life and saw as symbols in the world around them were supplemented by the vast assortment of fantastic animals that inhabited the realm of the unknown. At a time when most people never left the confines of their immediate towns, and the lands beyond Europe were only just beginning to be systematically explored, the possibilities of what lay beyond the known world could be exhilarating and sometimes frightening. Tales of giant creatures with elongated noses called elephants in the far-off land of India must have seemed as incredible to those in medieval Europe as stories of the sirens who could lure

sailors to a watery death by their distractingly beautiful songs. The realms of hell, with demons galore, also haunted those in the Middle Ages as a real place whose terrible beasts could only be dimly envisioned, while the horrors awaiting those witnessing the end of the world were graphically described in the Bible's book of Revelation, with its scorpion-tailed locusts, seven-headed beasts, and fire-breathing horses. Medieval artists let loose their imaginations in depicting these creatures of the unknown and went even further in creating fantastic animals to inhabit the margins of manuscripts. Vast numbers of extraordinary and far-fetched creatures—some humorous, some terrifying—cavort and frolic in the free spaces surrounding more sober illustrations.

Part of the great appeal of medieval manuscripts to the modern viewer is the seemingly infinite variety of beasts that swarm, creep, and scramble across their pages. We marvel at the skill of medieval huntsmen releasing their trained hawks into the sky, gaze with awe at the stately and composed forms of the symbols of the four evangelists, and shudder in enthralled horror at the sight of dragons with their great wings unfurled. It is the visual representations of these beasts that capture our imaginations because they strike a familiar chord in our own lives. The genial farm animals seen in the calendars of medieval devotional books have a descendent in the dog, cat, and horse calendars for sale each year in bookstores. The lions that flanked noblemen's coats of arms were status symbols as instantly recognizable to those in the Middle Ages as the silver jaguars that leap from the front of expensive cars today. Even the illuminated tales of strange and fearsome humanlike creatures living at the far ends of the earth are a medieval counterpart to the modern-day fascination with science-fiction movies in which otherworldly aliens with evil intentions mask themselves as human. Although we are separated from medieval culture by hundreds of years, this book celebrates the beasts that charmed, delighted, or even frightened medieval viewers, and still do the same for us.

ANIMALS IN DAILY LIFE

*Then God said, "Let the earth bring forth
living creatures after their kind: cattle
and creeping things and beasts of the
earth after their kind"; and it was so.
And God made the beasts of the earth
after their kind, and the cattle after their
kind, and everything that creeps on the
ground after its kind; and God saw that
it was good.*

GENESIS 1:24–25

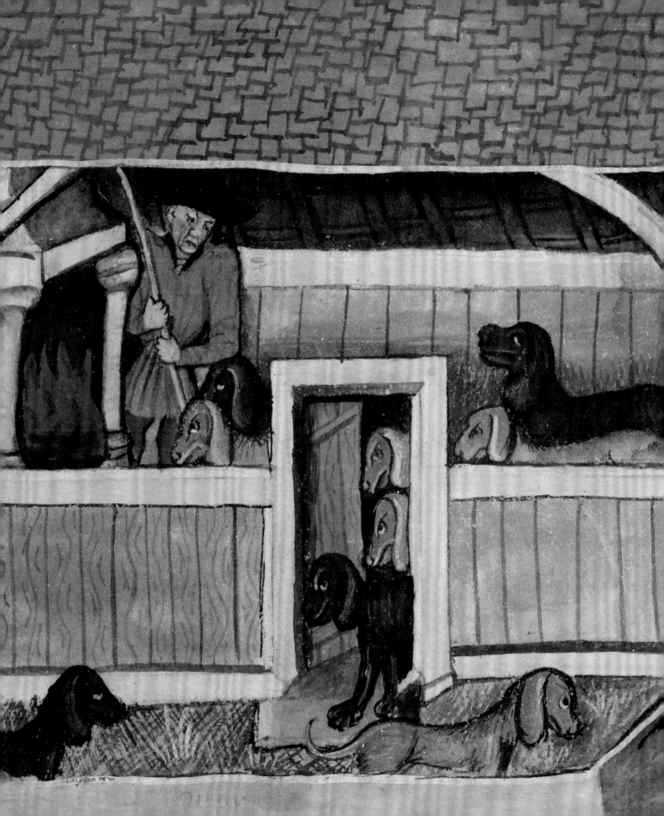

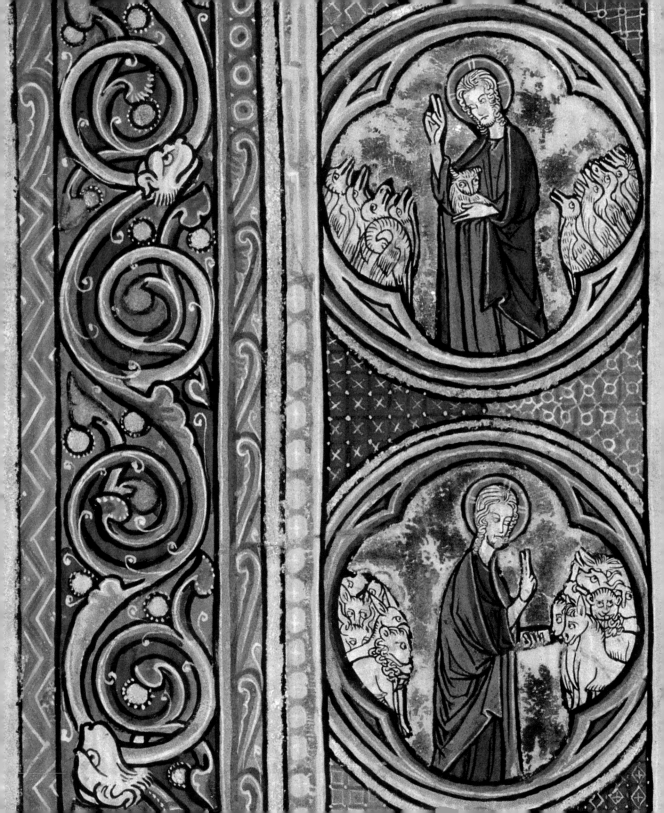

CREATING THE ANIMALS

The Bible begins with a poetic description of the formation of the earth—its cycle of light and darkness, its land and water, its plants and trees, and, not least, its living creatures. The story of the Creation was one of the most powerful narratives of the Middle Ages and one of its most frequently illustrated. In Genesis, God states that man is to have dominion over the beasts of the land, the fish in the sea, and the birds of the sky, and Adam's first duty was to name all the animals. To those in the Middle Ages, the close link between man and animal was, therefore, not only naturally dependent but also divinely ordained. Almost all illuminated Bibles began with a series devoted to this theme (fig. 1), and even devotional books would sometimes include an image of the Creation to encourage viewers to reflect on God's might and majesty by contemplating the wondrous creatures he had wrought (figs. 2, 3).

1

Initial I: Scenes of the Creation of the World

Marquette Bible

Probably Lille, ca. 1270

JPGM, Ms. Ludwig I 8, vol. 1, fol. 10v

ominica in septuagesi-
ma Sabbato precedenti Ad vs. R.
Igitur psalmum Ad vigint[?] i prea oro
reces po-
puli tui
quis co-
mie. cle-
menter
exaudi
ut qui...

iuste pro precis nostris affligi-
mur pro tui nominis glo-
ria misericorditer liberen
Per. Benedicamus domino
alla. alla. Ab hac die. usqz ad
vigilia misse pasche non di
catur alla. sz loco. alla. dicat
x. Laus tibi domine rex eter
ne glie. Ad matutinas. In
uitatoriuz. Preoccupem[?] fa

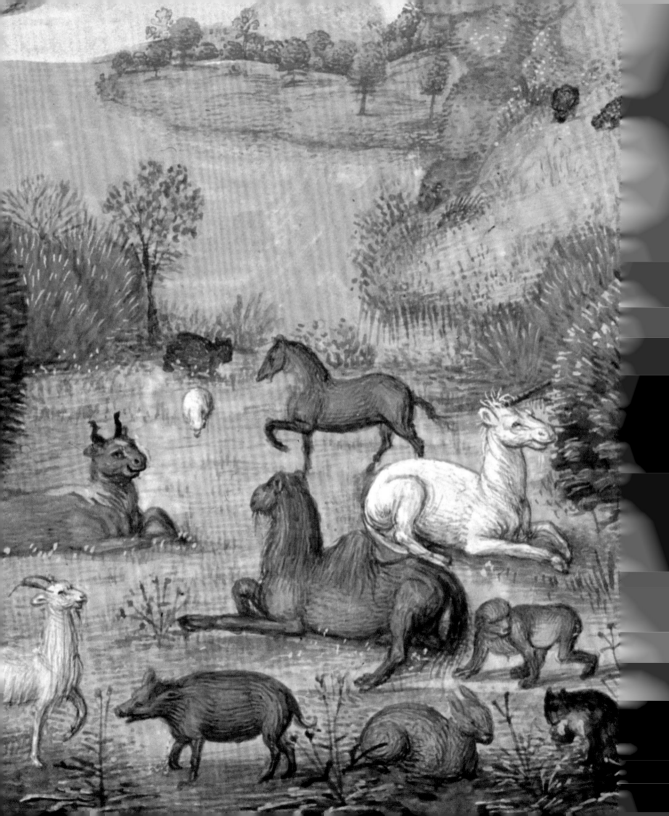

Ich wol spre
che vnd sage
danck dir o
hailige drey
hait, vn vn
zertrenliche ainigkait vatt
sun vn hailiger gayst, ain
warer almechtiger got wel
cher das du erklärteft deiner
güthait vnausprechenliche
miltickait haftu ain anfang
beschaffen himel vn erd, oz
mör vn alle ding dei ine
seind, vn haft für alle andere
creaturen mit sunderlicher ee
vn wirdikait de mensche erho

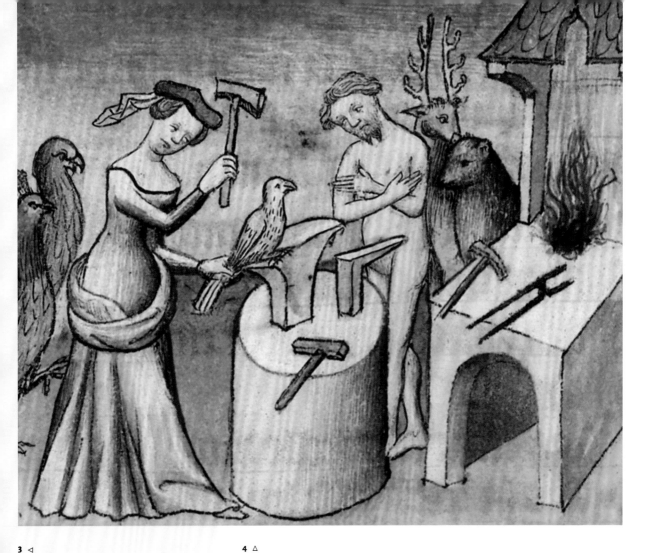

3 ◁

Border with the Creation of Birds and Fishes

Simon Bening

Prayer Book of Cardinal Albrecht of Brandenburg

Bruges, ca. 1525–30

JPGM, Ms. Ludwig IX 19, fol. 8

4 △

The Personification of Nature Making Birds, Animals, and People

Guillaume de Lorris and Jean de Meun,

Romance of the Rose

Paris, ca. 1405

JPGM, Ms. Ludwig XV 7, fol. 121v

Toward the end of the *Romance of the Rose*, the most famous allegorical poem of the Middle Ages, the character Nature creates both humans and animals on her anvil of life. She specifies, however, that God differentiates the forms she makes by endowing man alone with reason and an immortal soul. In this representation of creation, Nature forms the shells, after which God distinguishes man from all the beasts by the addition of the capacity for virtue and sin.

Besides land, animals were the most important economic commodity of the Middle Ages. A man's wealth and social position could largely be determined by the size of his herds and flocks as well as his ability (or inability) to participate in aristocratic pastimes such as hawking and hunting. The dependence of medieval culture on animals quickly becomes evident by looking at the illustrated prayer-book calendars of the period. The illustrations of these calendars take as their most common theme the Labors of the Month, a series of twelve scenes depicting the main agricultural task or aristocratic amusement of each month. The early spring sees the planting of fields using oxen and the arrival of newborns to augment the herds (fig. 6), in summer noblemen head out on fine riding horses accompanied by their hunting dogs (figs. 9, 26), and, as the prospect of winter approaches, the fattened cows are slaughtered to tide over the population until the next spring (fig. 5). In a rural society, the yearly cycle of activities carried out by landowners and their peasants revolved around the animals that sustained and supported them.

5 ▷

Calendar Scenes for October
Workshop of the Master of James IV of Scotland
Spinola Hours
Bruges and Ghent, ca. 1510–20
JPGM, Ms. Ludwig IX 18, fol. 6

◁
Calendar Scenes for June
Spinola Hours
JPGM, Ms. Ludwig IX 18, fol. 4

6 *(overleaf)*
Calendar Scenes for April
Spinola Hours
JPGM, Ms. Ludwig IX 18, fol. 3

		Luna xxx.	ix	c	Maximin m
rvi	a	Remigii epi	d		Luce euagel?
v	b	Crisp̃ clat	rvii	c	Ianuarii scio
xiii	c	Dñor ewaldor	vi	f	Quintini mr̃
ii	d	Fran̄ asa fes	g		xi milui vg̃
	e	Apolinatis c̃	viii	a	Seueri epi
x	f	Romani epi	iii	b	Seuerini am̃
	g	Marci pape		c	petri et alior
xviii	a	Regresoio v̄	xi	d	Crisãti z darie
vii	b	Dyonisii epi	xix	e	Amandi cõf̃
	c	Cerbonii epi		f	vigil̃
xv	d	Iusti mr̃s	viii	g	Symois z Iud
iiii	e	Felias mr̃s		a	Darasii cõf̃
	f	Tropheii epi	rvi	b	felic̃ z scio.
xii	g	Kalixti p̃e	v	c	vigil̃

LIBRA

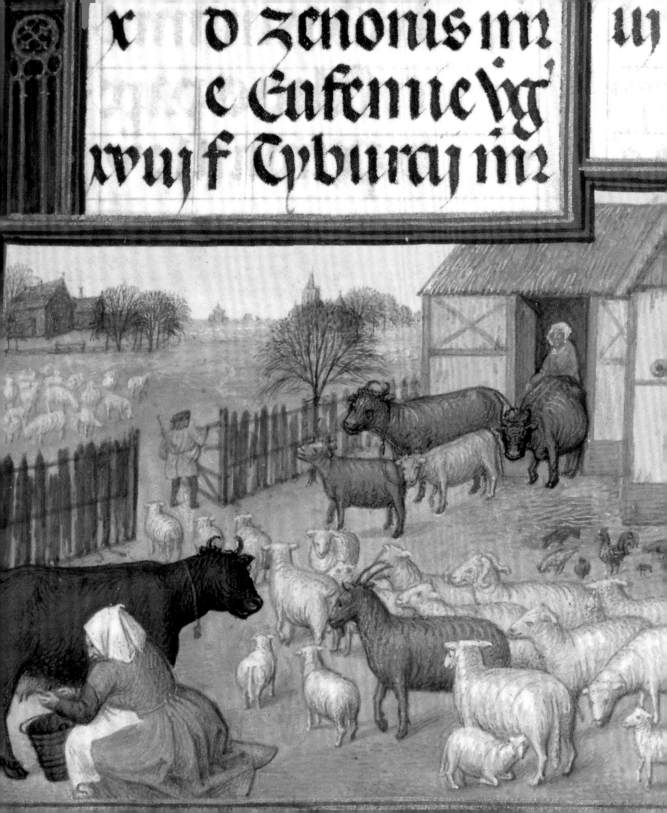

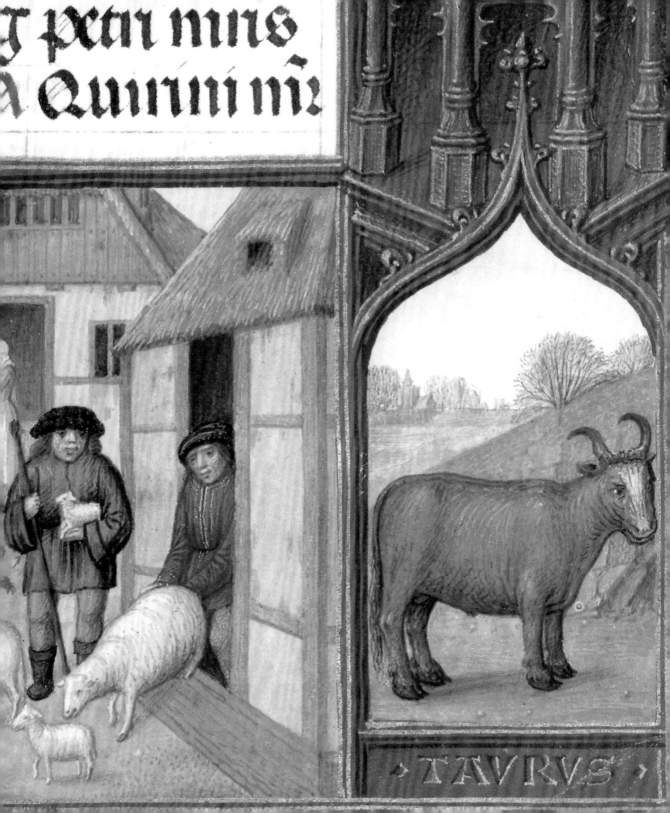

T petr mns
Quirini mr

TAVRVS

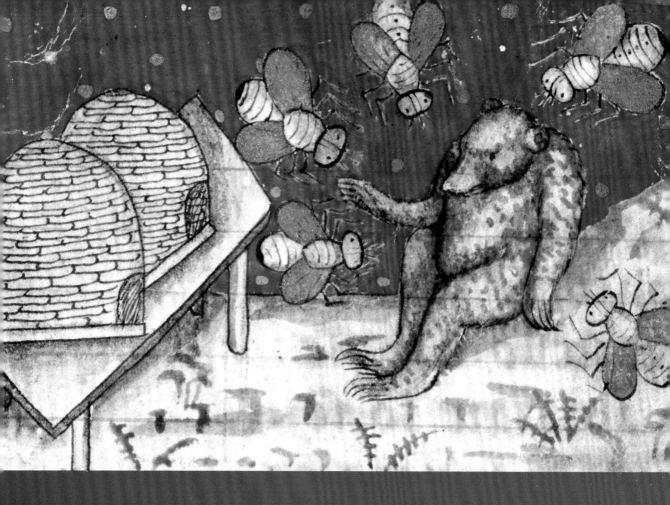

7 △

Bear with Bees and Beehives

The Flower of Virtue

Northern Italy, ca. 1400–1425

BL, Harley Ms. 3448, fol. 10v

Because sugarcane was not native to
Europe, honey was the primary sweetener
known in the Middle Ages. It was also used
to ferment alcoholic beverages, while
beeswax provided material for candles.
Each hive was specially marked by its
owner, and the only real threat to them was
attack by wild bears from the surrounding
forest, as in this representation of an
unhappy bear ineffectually swatting at a
group of oversize bees.

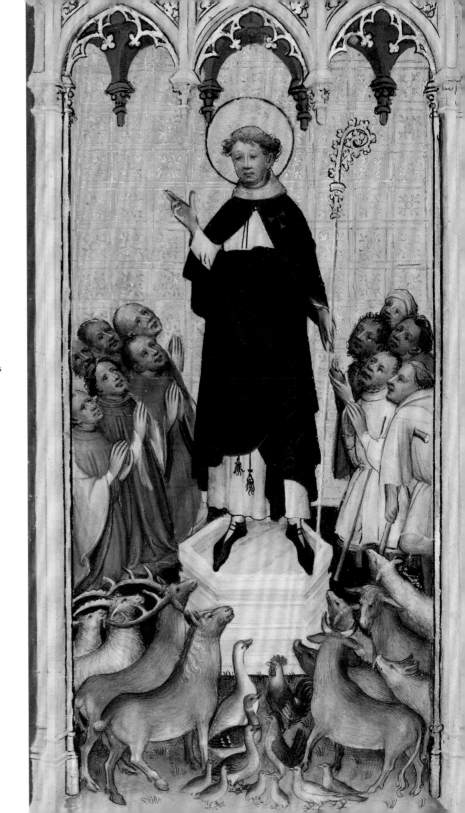

8 ▷

**Saint Anthony Abbot Blessing the Animals,
the Poor, and the Sick**

Master of Saint Veronica

Miniature, perhaps from a manuscript

Cologne, ca. 1400–1410

JPGM, Ms. Ludwig Folia 2, leaf 2

In the Middle Ages, if a virulent infection affected an entire flock or herd, a landowner could be faced with a disastrous economic loss. There was generally not much that owners could do except pray. Saint Anthony Abbot became known in the Middle Ages as the patron saint who protected animals from disease. Here farm animals of every sort turn their rapt attention to the saint, who raises his hand in blessing. Today, Anthony's feast day is still celebrated with blessing ceremonies for people's pets.

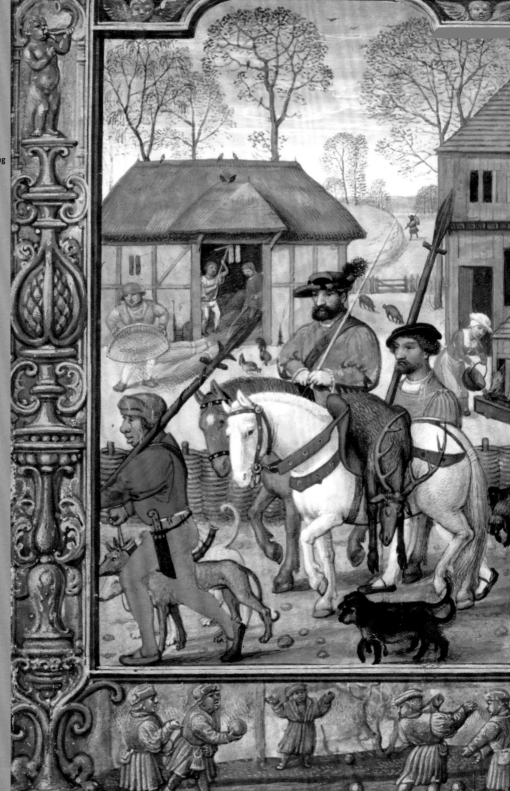

9 ▷
Huntsmen Returning
Workshop of Simon Bening
Golf Book
Bruges, ca. 1520–30
BL, Add. Ms. 24098,
fol. 28v

Unlike hunting dogs, which were thoroughly domesticated, medieval hunting hawks were caught wild after already having learned to hunt from their mothers. A wild hawk was netted and then either hooded or had its eyes sewn shut to make it accustomed to being dependent on human care. Once partially tamed, it would have its sight restored and be trained to return prey to its owner. In this image, the prince's hands are protected from the sharp claws of his hawk by heavy gloves, while the hawk gleefully partakes of its share of the returned prey.

10 ▽

A Man Hawking
Psalter
Flanders, ca. 1250
JPGM, Ms. 14, fol. 5

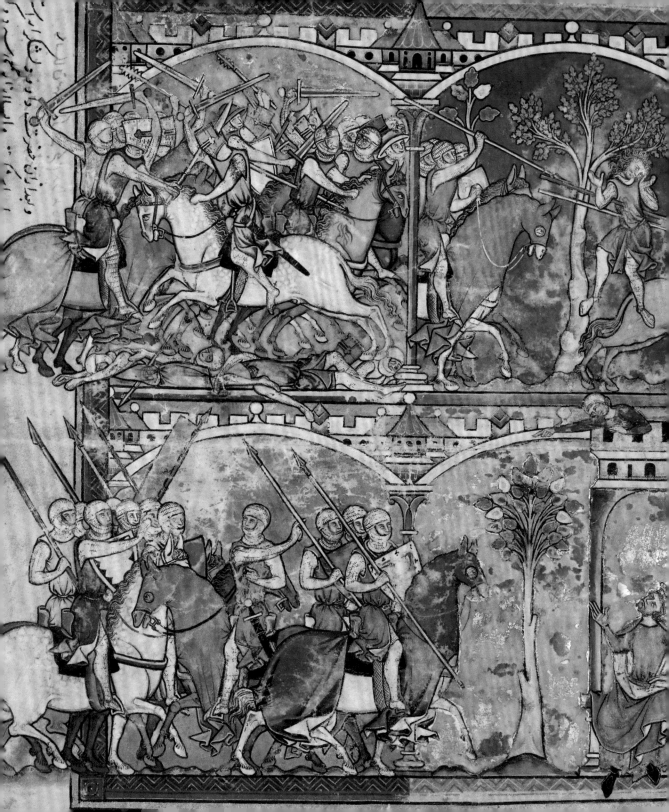

WARFARE

Animals in the Middle Ages were fundamental to the pursuit of war. The large warhorses called destriers in French were perhaps the most prized possession of noble knights (figs. 11, 12). It has been estimated that these specialized warhorses, bred for their courage, stamina, and size, would have cost as much as 800 times the price of a peasant's plow horse. The number of soldiers mounted on destriers that a leader was able to bring to battle could help determine the course of a war. People in the Middle Ages were also fascinated by romances and history books recounting tales of war in foreign lands. Legends of Alexander the Great's successes in the East or the more contemporary stories of the heroes of the medieval Crusades brought to mind exotic visions of war conducted from the backs of elephants, descriptions of whose sheer size and weight awed medieval readers (figs. 13, 14). In 1255, an elephant was even presented by King Louis IX of France to King Henry III of England for his menagerie at the Tower of London.

11 ◁

Scenes from the Life of Absalom

Leaf from the Morgan Picture Bible

Northern France, ca. 1250

JPGM, Ms. Ludwig I 6, verso

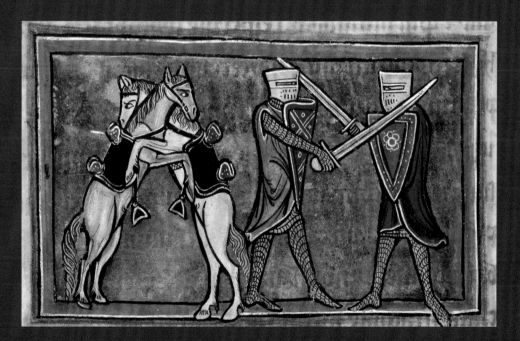

12 △

Horses and Knights in Battle

Bestiary

England, ca. 1230

BL, Royal Ms. 12 F.XIII, fol. 42v

Medieval bestiaries identified the horse as the most spirited of animals, eager for the smell, sound, and action of battle. The artist of this manuscript has portrayed the horses as animal equivalents to knights in combat. The horses are shown in the midst of a fierce struggle, just as their masters are. The bestiary goes on to recount that a horse will shed tears when its master dies, the only animal capable of this level of devotion and sorrow.

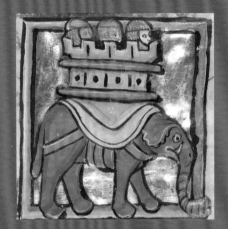

13 △
An Elephant Carrying Three Soldiers
Bestiary
Thérouanne?, ca. 1277
JPGM, Ms. Ludwig XV 4, fol. 104

14 ▷
The Land of India
Vincent of Beauvais, *Mirror of History*
Ghent, ca. 1475
JPGM, Ms. Ludwig XIII 5, vol. 1, fol. 55

This illumination from a manuscript
recounting the history of the world shows
the wonders of India. The elephant at the
center was probably included because the
animal is mentioned in the text as one of
the curiosities of that land. To judge from
the appearance of the doglike beast, the
illuminator had never seen a specimen in
person but knew of horns made from
elephant ivory and confused the elephant's
trunk with its tusks.

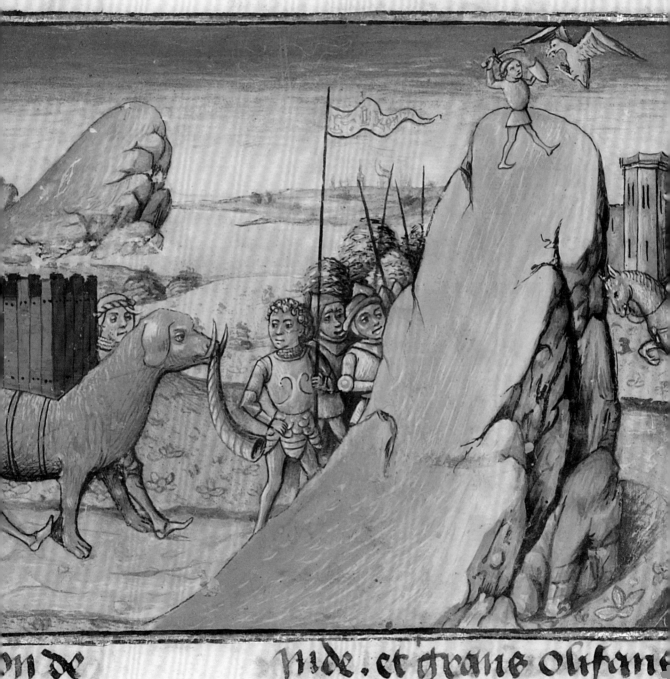

ANIMALS AND THE LAW

One of the ways we determine the importance of any single aspect of a culture is to look at what kinds of laws regulate it. The use and ownership of animals were so essential to medieval society that the law books of the time are filled with legal practices related to every aspect of animal husbandry. Crimes involving animals closely associated with the aristocracy—warhorses, hunting dogs, hawks—carried the heaviest penalties, followed by those linked to animals employed for labor, and, finally, those against animals used for food or clothing (fig. 15). Whole sections of legal texts were devoted to specifying penalties for a long and detailed list of offenses relating to animals, underlining the profound interdependence between man and beast in the Middle Ages. For example, there were laws that not only stipulated a specialized penalty for the theft of a breeding ram rather than a common sheep (fig. 16) but also compared degrees of human loss in terms of animals. One such law states that one tooth of a nobleman was worth twice the value of the most cherished falcon, while a peasant's tooth was worth only the value of a single hunting dog.

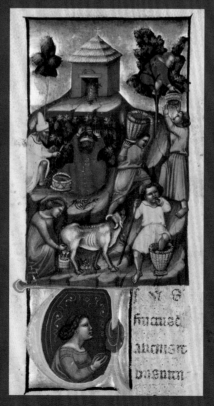

15
Harvest Scene
Attributed to the Illustratore
Cutting from Justinian, *Digest*
Bologna, ca. 1340
JPGM, Ms. 13, verso

The group of civil laws gathered together by the Byzantine Emperor Justinian remained influential throughout the Middle Ages. This harvest scene illustrates the section of the text devoted to property and its use. Naturalistic details, such as the woman milking the cow in the foreground, were added by the artist to give a vivid realism to the otherwise dry text.

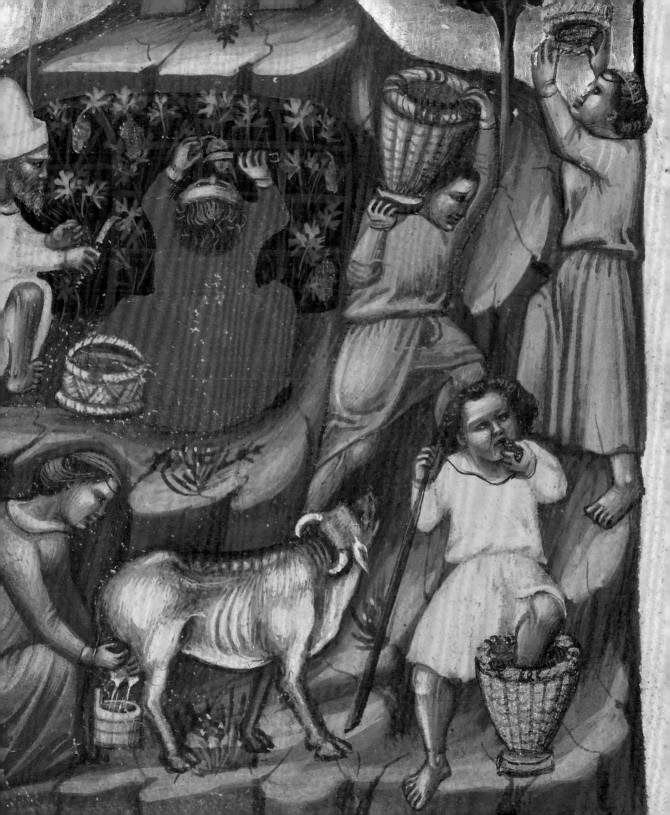

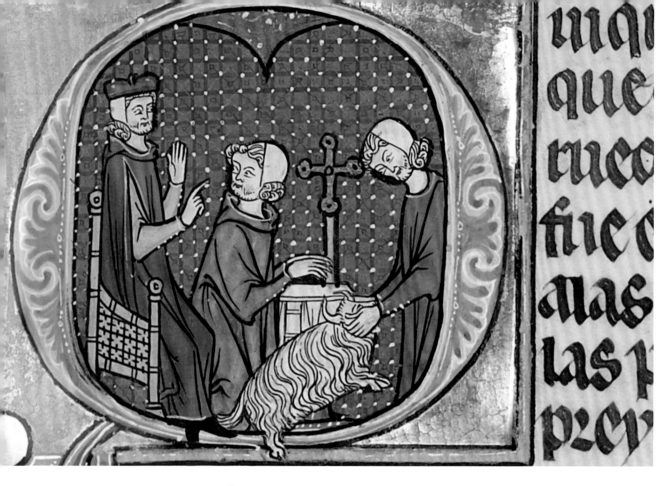

uiq
que
tuco
fuc
alas
las p
p2cp

16 △

Initial Q: A Judge Pointing to Two Men with a Ram

Feudal Customs of Aragon

Northeastern Spain, ca. 1290–1310

JPGM, Ms. Ludwig XIV 6, fol. 136

The text accompanying this miniature in the law codes of the Kingdom of Aragon relates that if a thief steals a breeding ram, he will have to pay back the owner of the original animal with a ram of equal capability and value. In the miniature, the all-important testimony of the shepherd is emphasized by the fact that he swears before an altar. The ram, perhaps the original animal being returned to its master, also appears as part of the case.

17 ▷

Initial S: A Judge with Two Men Pointing to Two Peacocks

Feudal Customs of Aragon

JPGM, Ms. Ludwig XIV 6, fol. 142

Another image from the same manuscript shows the case of a man who was attacked by vicious birds belonging to another man. The injured party points in obvious distaste to the largest of the birds. The law provides that he will be able to keep the birds in his possession until the original owner makes restitution. The bizarre specificity of the case makes one wonder if Alfred Hitchcock ever read medieval legal manuscripts.

lo que se sigue. Si qd zu pes t
bipes paupie fcasse dicatur.
Es assaber si cosa de quatro
pies o de dos pies fiziere da
ynno.—

llos pao
nes. gall
unas. pa
lombas.
o q̃les sea
ere cosas
de dos pie
tes. o de quatro pies. o de z
mas pies assi como sõ abeil
las fizieren dayñno adalgu
no. en qual se q̃ere guisa. el
qui recebio el dayñno poz a
pendzar todas estas cosas
antedichas danto pmeramt
testigoy poz este dayñno. Et
tenia aquilos pēyñnoz daqui

tan ayna comode
los alienanos de
en que las abeilla
panares. z tan ayñn
entraren que sea
uaso con el pãnno
poz ont entraren
re sallir. a taq̃z ac
bio el dayñno sea
plidamentodaqui
queillas abeillas
anta folia f
a delos bail
tos qui offitio te
obidando adius
z enemiga. poz q̃
achaquia ganau
ganantias mas.
poz si. z poz sus
entre las quoales
les fue estabid o

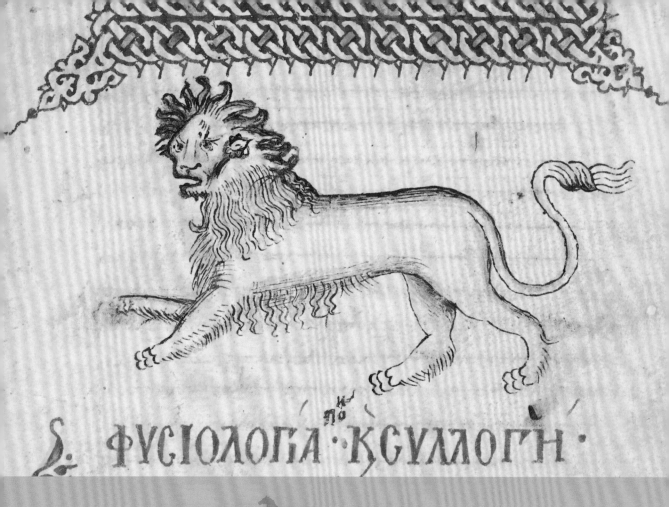

ФΥСΙΟΛΟΓΑ · ΚϹΥΛΛΟΓΗ ·

STUDYING ANIMALS

Although the practice of studying nature in the Middle Ages differed quite significantly from the kind of biological research that is undertaken today, medieval scholars and artists had a lively interest in the physical world and its workings. One of the earliest treatises devoted to the study of animals was the Greek *Physiologus*, a book compiled for instruction at the Greek court in the second century A.D. (fig. 18). It examined the appearance and behavioral traits of individual animals and then ascribed to these attributes a moral or Christian meaning. The *Physiologus* was translated into Latin and developed into the bestiary, one of the most popular types of books of the High Middle Ages. Bestiaries could include over a hundred different animals, fishes, and birds and were often lavishly illuminated (fig. 19). In the later Middle Ages and Renaissance, scholars and artists turned their attention toward close observation of the natural world and produced wonderfully realistic representations of animals based on firsthand study (figs. 20, 21).

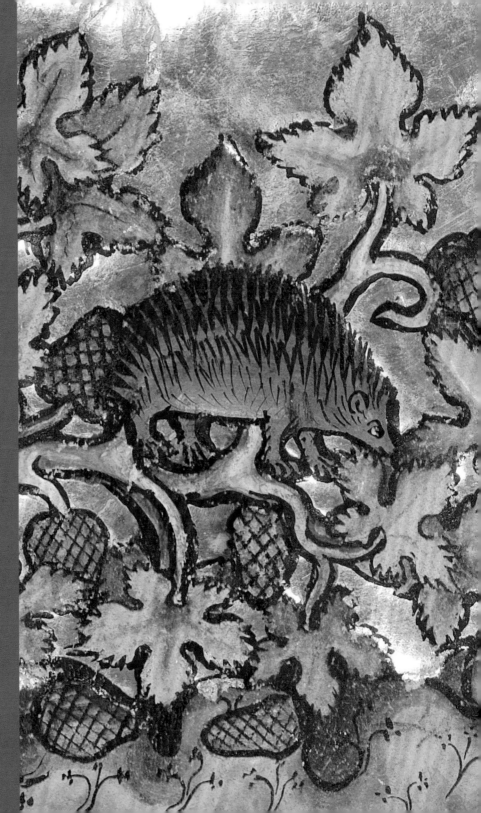

According to this Greek text on natural history, the lion is the mightiest of the beasts and is so clever that it hides evidence of its presence from hunters by covering its own tracks. The text goes on to explain that the lion is therefore a symbol for the Lord, who was able to hide evidence of his divine nature from unbelievers. The artist of this manuscript, however, was clearly more concerned with rendering an accurate physical representation of the lion, with its bristling mane, fluffed tail, and outstretched paws, than showing any of its symbolic attributes.

21 ▷
A Sloth(?)
Joris Hoefnagel
Model Book of Calligraphy
Vienna, ca. 1591–96
JPGM, Ms. 20, fol. 106

The Renaissance saw the advent of an intense interest in the realistic depiction of the natural world among artists, including Joris Hoefnagel. He studied plants, insects, and animals firsthand before incorporating them into his artistic creations. Here a wonderfully naturalistic creature munches unconcernedly on a wooden twig; the tufts of fur on his ears and his clumsy paws make him an irresistible specimen.

20 ▽
A Pig or Boar
Herbal
Lombardy, ca. 1440
BL, Sloane Ms. 4016, fol. 77

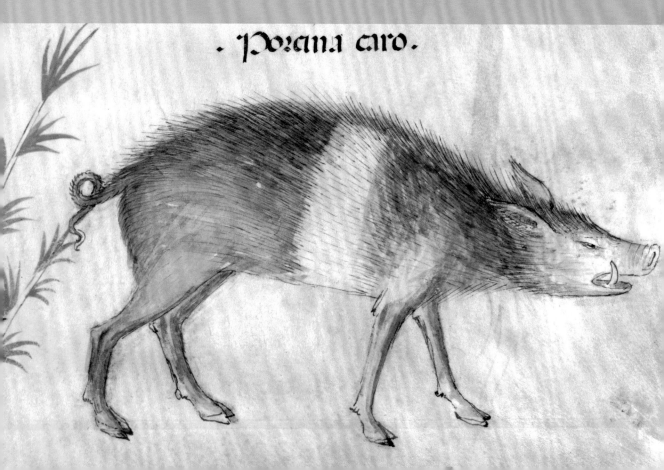

· Porana caro ·

BEATI ILLI, QVI SVBVENI=
VNT MISERIS: QVONIAM E=
IS REPENDITVR, VT PER

MISERICORDIAM DEI DE MI=
SERIIS LIBERENTVR: NAM
IDIPSVM VIDETVR IVSTVM
VT QVI A POTENTIORE A=

DIVVARI VVLT, ADIV=
VET INFERIOREM IN
QVO IPSE EST POTENTior

MISERICORDIA LARGIOR, VBI FIDES PROMPTIOR. NIHIL
TAM COMMENDAT CHRISTIANVM, QVAM MISERATIO CHAR=
ITATIS. ANNO DOMINI. M·D·LXI. Ç·

BEASTS IN FOCUS: THE HUNTING MANUAL

Hunting was the favorite aristocratic sport in the Middle Ages, and the *Book of the Hunt* was the most popular guide for noblemen interested in hunting. The text's author, the Count of Foix, Gaston Phébus (1331–1391), was himself an enthusiastic hunter and owned sixteen hundred dogs and two hundred horses. His comprehensive treatise written for the Duke of Burgundy, a fellow hunting enthusiast, discusses topics ranging from the types of animals to hunt, to the care and training of dogs, to the various methods of stalking prey. In this manuscript, the flattened space and highly stylized conception of the animals as well as the landscapes they inhabit are reminiscent of contemporary tapestries, an art form that—like hunting— was something only the aristocracy could afford.

Book of the Hunt by Gaston Phébus

Breton, ca. 1430–40

JPGM, Ms. 27

22 ◁

Hares, fol. 16

The hare is a rather common animal, and there is no point in describing it here, since almost everyone has seen one. They live on wheat and other pasturage, on grasses, leaves, tree bark, on grapes and other fruits. The hare is a very good small creature, and hunting it is more agreeable than hunting any other beast in the world.

23 ▷

Wild Boars, fol. 21v

Of all the animals in the world, this is the one that has the strongest weapons and that would soonest kill a man or a beast; and there is no beast that it would not kill one on one, rather than being killed by it, even the lion or the leopard, unless they jumped on its back, there where it can't reach them with its tusks.

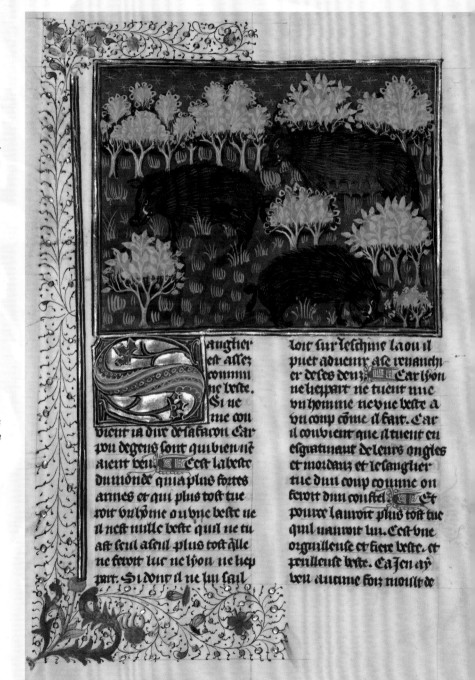

24 ◁

Dogs, fol. 30

After what I have said about the nature of the beasts that one chases, including both the docile and biting ones, I am going to talk about the nature of the dogs that chase them, of their nobilities and characteristics that are so great and marvelous in certain dogs that there is no one who could believe it . . . because the dog is the most noble animal, the most sensible and the most wise that God ever made.

25 ◁

A Hunter Attending to Kenneled Dogs, fol. 46

The kennel must be big and wide, if there is a great quantity of dogs. It must have a door at the front and another at the back, and behind it, a pretty meadow where the sun shines all day, from sunrise to sunset. The back door must be left open all the time, so that the dogs can go outside into the meadow to play whenever they want, because it is good for dogs to be able to come and go as they please, for if not, they can become mangy.

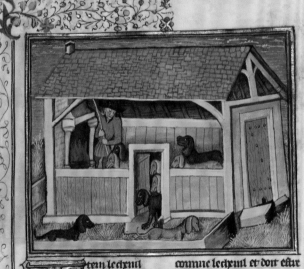

K ten le chenil
doit estre grāt
de. x. toises de
long et cinq de
large sil ya gst
foison de chiens
et doit auoir vne porte deuāt
et vne autre demer vn beau
prael ou quel le soulail se
voie tout le iour des quil le
ueue iusques atant quil se
couchra. ☙ Et celui prā
el doit estre en muroitre de
palaise ou de terrasse ou mur
dautant de long et de large

comme le chenil et doit estre
la porte demere tousiours ou
uerte affin que les chiens pu
issent aler dehors esbatre ves
le prael quant leur plaist
car trop grant bien fait a
chiens quant ilz puent aler
de de; et dehors la ou leur plaist
et plus tart en sont vigneux
☙ Et doit auoir ou chenil
prtis batons fichiez en terre
et en toreilles de paille hors
de leur litiere iusques a vij. af
fin que les chiens viennent
pisser la. ☙ Et doit auoir

26 ▷

Hunters Pursuing a Deer, fol. 61v

It is necessary, once a new servant knows how to find and divert deer and wild boar, that he also thoroughly understands at what point to let the hounds go. Therefore, when he leaves the assembled hunters it is necessary for him to put himself in front of all the others, his hand holding his bloodhound behind him, up short near the collar, and whatever signs of prey he sees, he must call out, "See, it went through here!"

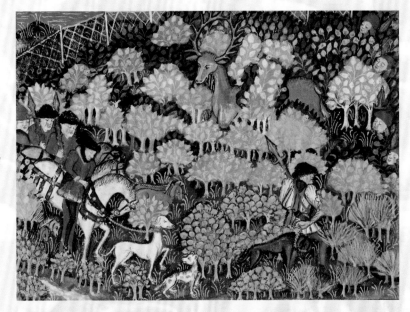

27 ▷

A Camouflaged Horseman and an Archer Approaching a Deer, fol. 110

There is still another manner of hunting that is appropriate for poorer people: a man rides on a horse, flanked by an archer on foot; and when they see that they are near enough, the bowman remains on the spot, while the man on the horse goes on his way: the prey will wait and look at the man on horseback, and the bowman will be able to adjust his shot and aim at his leisure.

SYMBOLIC CREATURES

The Lord created different creatures with different natures not only for the sustenance of men, but also for their instruction, so that through the same creature we may contemplate not only what may be useful to use in the body, but also what may be useful in the soul For the whole world is full of different creatures, like a manuscript full of different letters and sentences (or meanings) in which we can read whatever we ought to imitate or flee from

Thomas of Chobham, thirteenth century

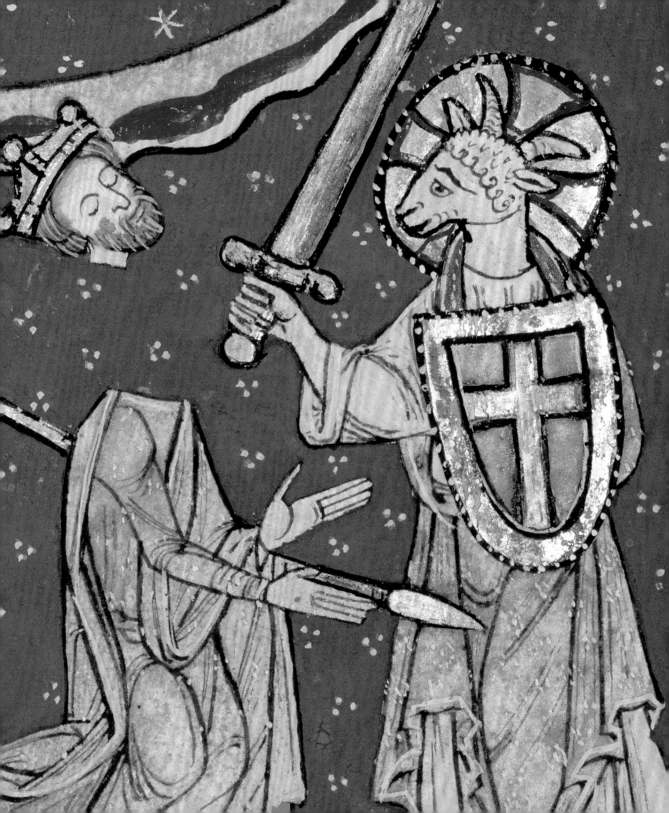

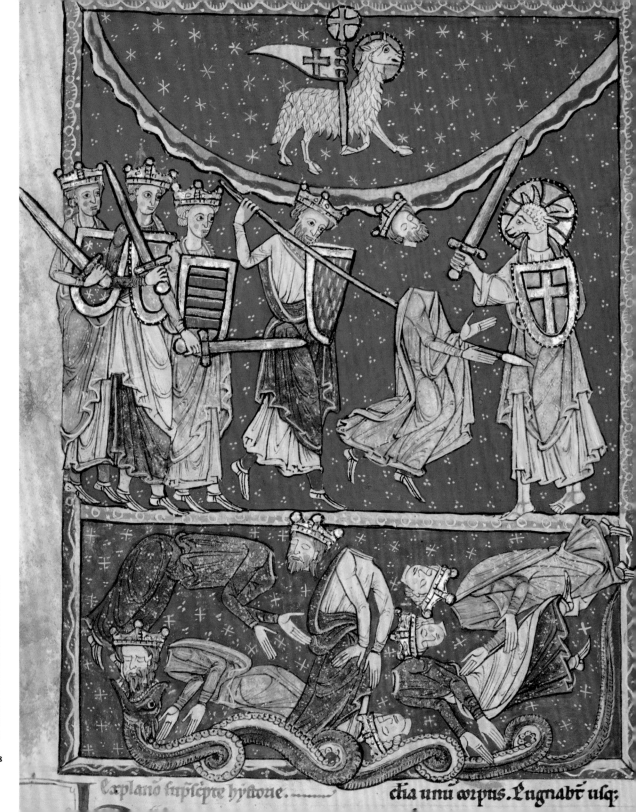

explano suplepte hyltone............ cia unu corpus. Lugnabr ulq;

CHRISTIAN SYMBOLS

In the Middle Ages, the vast majority of the population was deeply steeped in the Christian tradition. God had carefully designed the world, and therefore every aspect of nature, including its animals, intrinsically held evidence of God's great plan. The Bible was one of the most important sources for identifying symbols of the divine in certain animals. The New Testament compares Christ, who willingly died for the sins of humanity, to a lamb (fig. 28), an animal often found in Old Testament sacrificial rituals. The Old Testament figure of Ezekiel provided one of the most enduring sets of Christian symbols of the entire Middle Ages in his prophetic vision of four winged creatures—man, lion, ox, and eagle—which were later interpreted as symbols of the four evangelists: Matthew, Mark, Luke, and John (figs. 30–32). These animals that were commonly linked to a specific Christian meaning became so deeply ingrained in the medieval consciousness that they became some of the most often-repeated and instantly recognizable symbols in medieval art.

28 ◁

The Lamb Defeating the Ten Kings
Leaf from Beatus of Liébana, *Commentary on the Apocalypse*
Spain, ca. 1200–1250
JPGM, Ms. 77, recto

Skillfully wielding a sword, the Lamb of God (Christ) is presented in the guise of a medieval knight decapitating his foes. This miniature comes from a manuscript of the Apocalypse, the biblical account of the end of the world, which casts the events surrounding the end of time in the form of an epic battle between good and evil. Here the Lamb of God wages war against the evil kings of the world and, ultimately, triumphs.

29 ▷

A Pelican Feeding Her Young
Physiologus
Crete, ca. 1510–20
JPGM, Ms. Ludwig XV 2, fol. 150

This work on natural history states that one of the behaviors associated with the pelican is her willingness to pierce her own side to revive her chicks from death with the blood of her body. This was understood as a parallel to Christ, who redeemed humanity by the sacrifice of his own blood. In this image, the pelican tenderly bending over her chicks is surrounded by a ring of shimmering gold, evoking the heavenly connection.

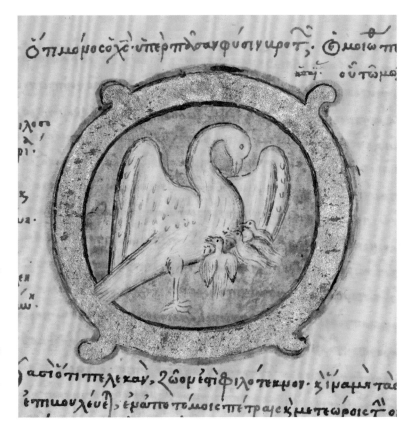

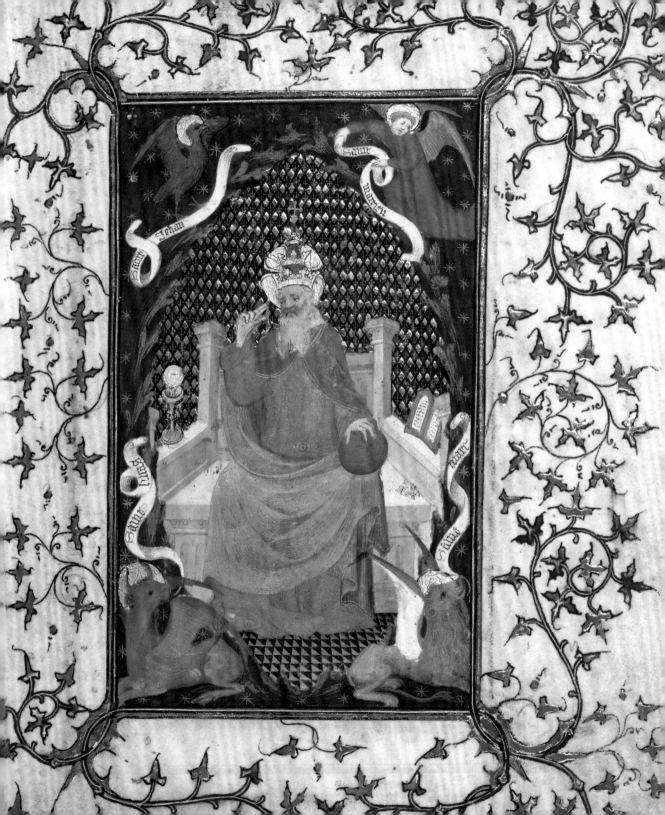

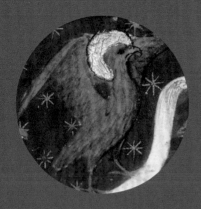

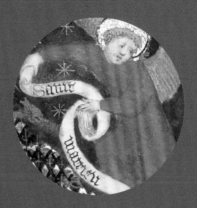

Saint John
EAGLE

Saint Matthew
MAN

30
Christ in Majesty Surrounded by the Symbols
of the Four Evangelists
Pseudo-Jacquemart de Hesdin
Book of hours
Probably Bourges or Paris, ca. 1410
JPGM, Ms. 36, fol. 1

The four evangelists, who wrote the four
Gospels of the New Testament, were
each traditionally associated with one of
the "four living creatures" witnessed in
a vision sent by God to the prophet
Ezekiel. Each creature represents a dif-
ferent aspect of Christ or God: the man,
Christ's humanity; the lion, his kingship;
the ox, God's power; and the eagle, his
all-seeing eye. The four symbols in this
image surround the majestic figure of
Christ, whose story they recorded.

Saint Luke
OX

Saint Mark
LION

Passio thu et sepultura et resurrectio ei.

Expliciunt capitula·

Incipit euuangelium secun
dum iohannem· capitl'm· v·

n principio erat uerbum. Et
uerbum· erat apud dm. Et deus
erat uerbum. hoc erat in prin
cipio apud dm. Omnia p ipsu
facta sunt · & sine ipso factum
est nichil. Quod factum e· in
ipso uita erat. Et uita· erat lux
hominum. & lux in tenebris
lucet · et tenebre eam n comp
henderunt. fuit homo missus
a deo · cui nomen erat iohannes.
Hic uenit in testimonium · ut
testimoniu phiberet de lu
mine · ut oins crederent per
illum. Hon erat ille lux · sed ut
testimonium phiberet de lumine.
Erat lux uera · que illuminat

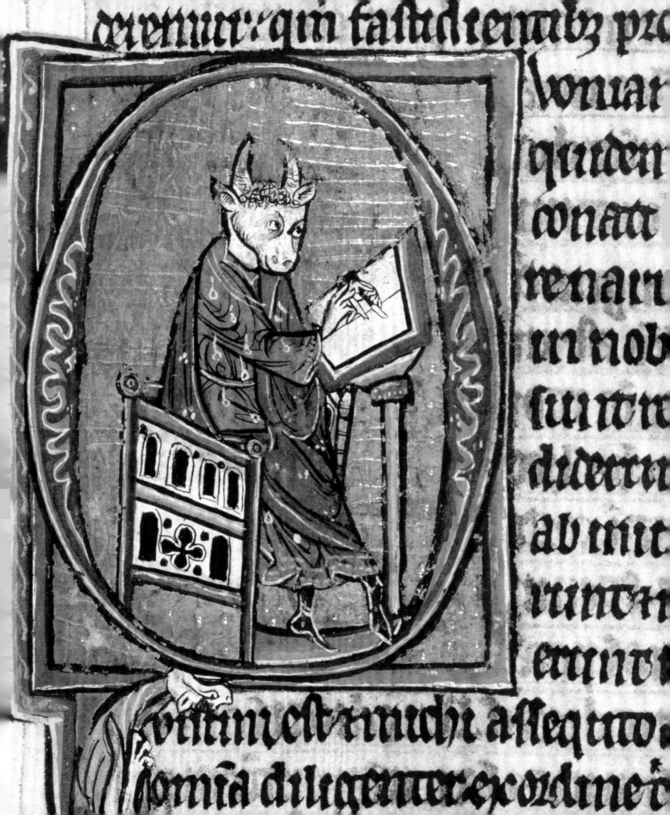

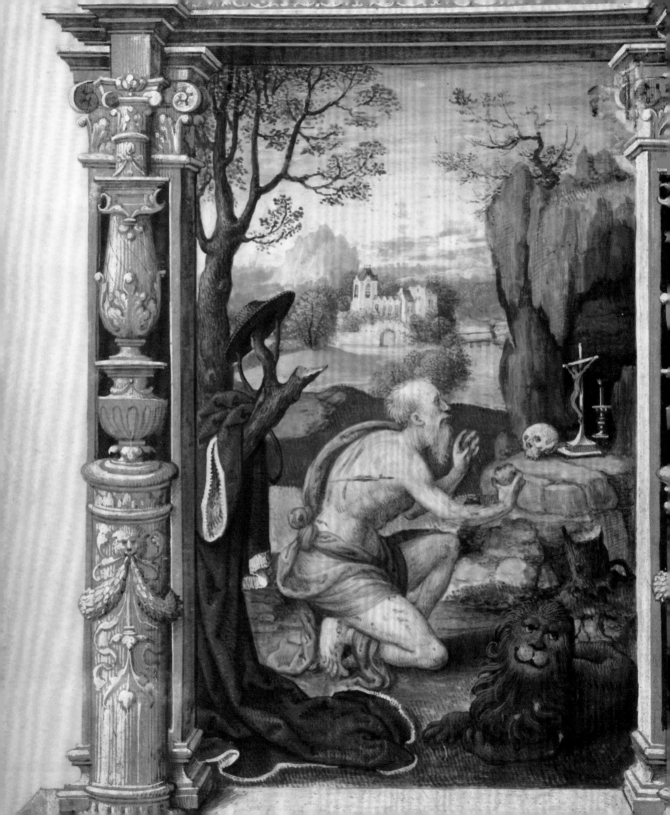

33
Saint Jerome
Master of the Getty Epistles
Getty Epistles
France, ca. 1520–30
JPGM, Ms. Ludwig I 15, fol. 1v

One day as Jerome was sitting with his fellow monks listening to a sermon, a lion limped toward the cloister. Jerome calmly greeted him and fearlessly examined his paw, finding and removing several thorns. After this, the lion became Jerome's tame companion wherever he went. In this image, the lion serenely looks out at the viewer as Jerome performs his prayers.

SAINTLY COMPANIONS

Because the animals of the earth were seen in the Middle Ages as God's creatures, it was not unusual for stories to recount how they could recognize the special qualities of a particular individual who was unusually devout and good (figs. 33, 36). A saint's animal companion could frequently perform tasks well beyond the capabilities of those observed in a normal creature, given special abilities through God's favor (fig. 35). An animal could also become a symbol for a particular saint due to associations with events that happened after the saint's death (fig. 34). The saints' biographies widely read throughout the Middle Ages by audiences ranging from monks to noble-women often included these animals, who, in their very innocence, could recognize a person's inherent qualities of sanctity and thereby attest to his or her saintliness.

34 ▷

Saint Anthony
Master of the Beaufort Saints
Beaufort Hours
London?, ca. 1410
BL, Royal Ms. 2 A.XVIII, fol. 6v

The association of Saint Anthony with a
pig likely arose not because of a lifelong
animal friend but because of social cir-
cumstances that prevailed in the Middle
Ages long after his death. It is thought
that the pig became Anthony's symbol
either because the monastic order that
took him as their patron saint obtained
special permission from the pope to
allow their pigs to roam freely in
medieval towns, or because Saint
Anthony was known as a patron saint
for skin diseases, which were often
treated with the application of pig fat.
In either case, the appearance of Saint
Anthony with small pigs was common
by the later Middle Ages.

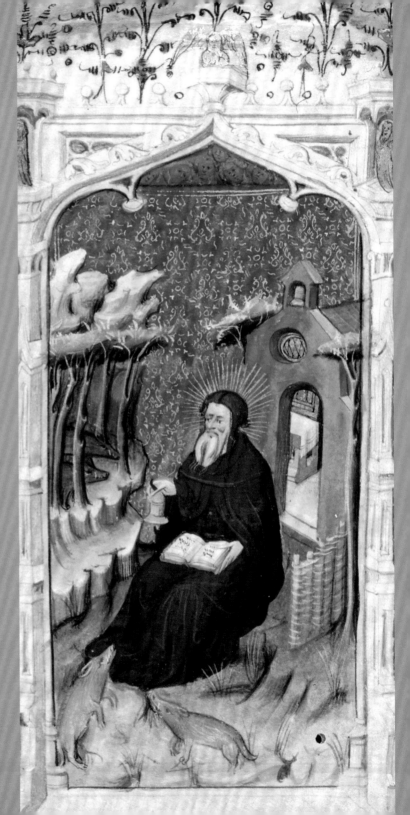

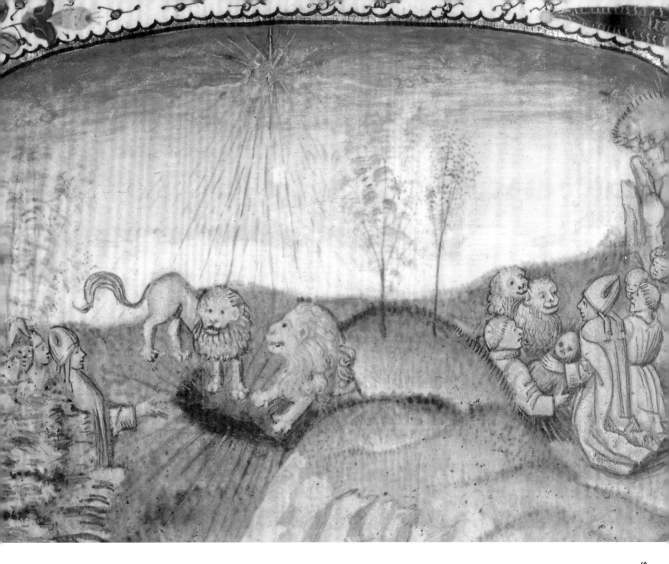

35 △

**Lions and Bishop Theophile Finding the Grave
of Saint Anthony**

Master of the Brussels Romuléon or workshop
*Invention and Translation of the Body of
Saint Anthony*
Probably Brussels or Bruges, ca. 1465–70
JPGM, Ms. Ludwig XI 8, fol. 29

In the seventh century, Bishop Theophile
set out on a quest to the Egyptian desert
to find the secret grave of Saint Anthony,
who had died in 356. Miraculously, two
noble lions led him to the spot where
Anthony had been buried and helped
reveal the grave. A brilliant star shines
down on the lions and the grave, while,
to the right, the lions can be seen again
with the bishop as the relics of Saint
Anthony are removed.

47

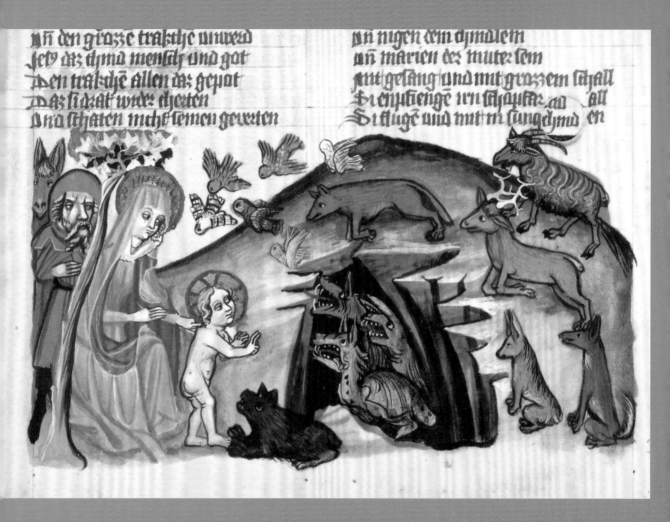

36 △

The Animals Recognize Jesus

Rudolf von Ems, *World Chronicle*

Regensburg, ca. 1400–1410

JPGM, Ms. 33, fol. 249

Because little of Christ's childhood is revealed in the Bible, infancy narratives of his life were popular during the Middle Ages. One episode concerned the ready recognition of the child Jesus by wild animals. Christ, as God incarnate in the world, was the master of all creatures; thus, in this image, instead of attacking the Holy Family, they kneel down before their sovereign. Even the normally ferocious dragons seem eager, rather than threatening, when they see the small child walking fearlessly toward them.

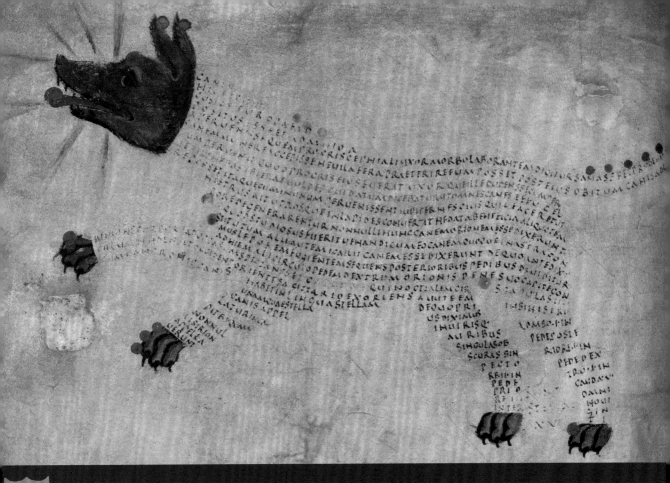

ASTROLOGICAL ANIMALS

Although astronomy and astrology are today considered completely separate disciplines, in the Middle Ages the two subjects were fully intertwined. The constellations and their relative positions in the sky provided much of the study material included in textbooks for astronomers and astrologers, and many of those constellations take the form of animals. Besides the well-known animal star formations that are associated with the twelve signs of the zodiac, such as Taurus, Aries, Cancer, and Leo (fig. 39), other constellations familiar in the night sky also take on the shape of animals: Canis Major (a dog; fig. 37), Ursa Major and Minor (the Big and Little Bears; fig. 38), and even Orion the hunter on his nightly quest to capture Lepus (a hare). The astrology columns we read in newspapers today still associate particular elements of the zodiacal signs with their animal representatives: those born under the sign of Leo (a lion) are thought to be proud and bullying, whereas the sign of Pisces (fish) is considered to be a water sign ruled by Neptune, the planet named for the Roman god of the

37 △

Sirius

Harley Aratus

Diocese of Rheims, ca. 820–40

BL, Harley Ms. 647, fol. 8v

This early medieval manuscript represents the various constellations as not only composed of stars but also of the very words that explain and elaborate on their positions in the sky and their meaning. Here the Dog Star, Sirius, forms part of the constellation Canis Major (Latin for "large dog"), which runs along in the night sky next to its master, the hunter Orion.

stellarum in signum aliquod formate ul' fabulose uariarum genera
formaru in celum recepta creduntur. Quor nomina no nature insti-
tutio. sz humana psuasio que stellis imos ⁊ eo nomina fecit aduenit.
Sz q ineti arciu numeris stellarum unicuiqz signo asscriptus est
eo quod ab ipo est ordine digesta descripco proferatur.

Mercules qui ⁊ ingeniclo dr̄ ht̄ stellā
i capite .i. i brachio .i. i humʼ singlʼ clarā
i sinistro cubito .i. i ipa manu .i. i utroqz lat̄
.i. i dext femore .ij. in pede .i.
sup dextrum manum .i.
i pelle leonis .iij.
summa .xvj.

Cmosura arctus minor ht̄ stellas i uno latere
.viij. claras i quadro positas i cauda claras .iij.
fiunt .vij. sub hiis apparet uelut qd uocat polus
cta qd putat toti orbi lucere.

Serpent q inter arcturos mediu iacet habet stellas in
capite claras .v. in corpe toto toto .xo ⁊ fiunt .xv.

Corona ht̄ stellas .viij. ⁊ orbe positas qr
iiij. clare q contra capud serpentis sep
tentrional' sunt.

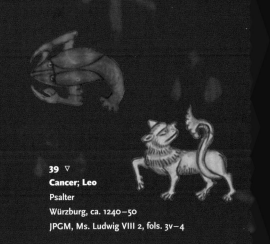

38 ◁
Constellation Diagrams
Astronomical Miscellany
England, early 1300s
JPGM, Ms. Ludwig XII 5, fol. 149v

On this page, the constellations Ursa Major and Ursa Minor are depicted as a large bear and a small bear, although today we call them, respectively, the Big Dipper and Little Dipper. Astronomy was considered one of the basic fields of study at medieval universities, and manuscripts such as this one, with lively line drawings, were probably compiled for students.

39 ▽
Cancer; Leo
Psalter
Würzburg, ca. 1240–50
JPGM, Ms. Ludwig VIII 2, fols. 3v–4

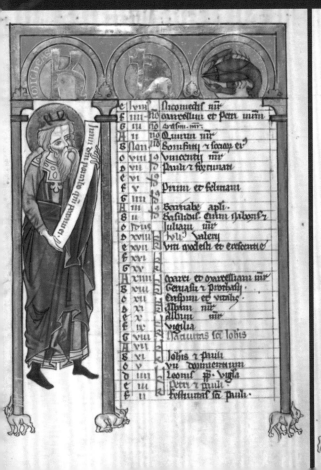

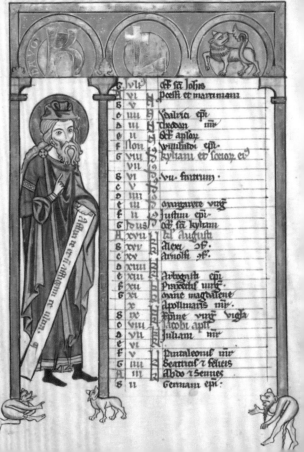

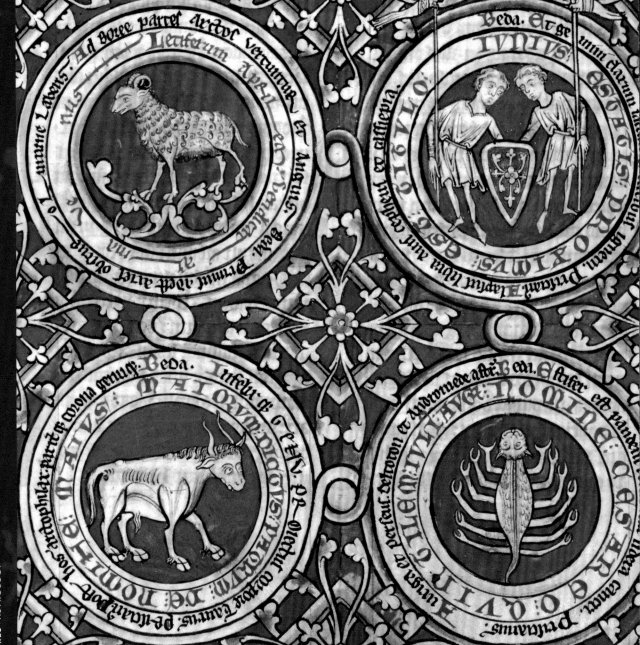

40 △
Astrological Signs
Bede, *Of Natural Things*
England, ca. 1243
BL, Egerton Ms. 3088, fol. 16v

HERALDIC CREATURES

Some of the most common elements of medieval heraldry are the dignified animals that flank and support the family shields of the nobility. Dogs, lions, unicorns, and bears, among others, proudly attested to the qualities of the families that took them as their symbols. There were various reasons that people chose different animals for their heraldic devices. A person might have felt that his character reflected the qualities of a certain creature, such as a unicorn's purity or a dog's fidelity (fig. 41). A particular animal might also have called to mind a specific aspect of appearance or ability, such as the massive strength of an elephant or the superb sight of a lynx (fig. 44). Animals ranging from ants to beavers to ostriches were chosen by members of the nobility, and sometimes fantastic creatures that defied categorization were invented when real animals failed to capture a nobleman's spirit (fig. 43). These coats of arms appeared in all sorts of medieval books, both secular and religious, acting as stamps of ownership and marks of noble status.

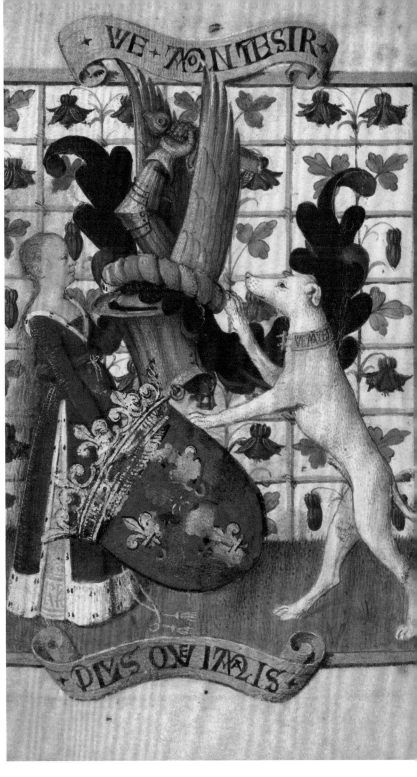

41 ▷
Coat of Arms Held by a Woman and a Greyhound
Jean Fouquet
Hours of Simon de Varie
Tours, 1455
JPGM, Ms. 7, fol. 2v

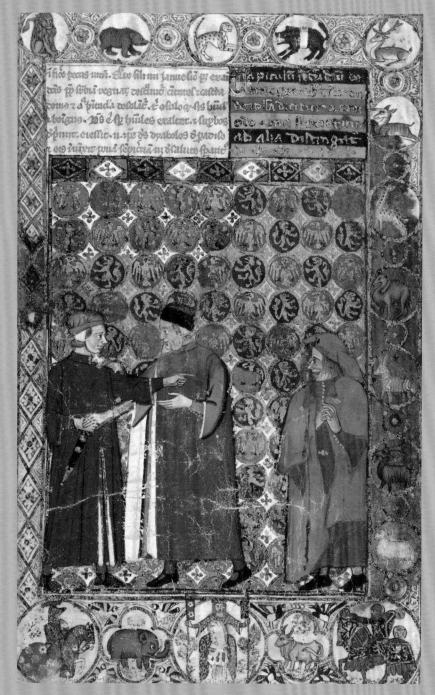

42 ◁

Figures with Animal Border
Cocharelli, *Treatise on the Vices*
Genoa, late 1300s
BL, Add. Ms. 27695, fol. 3v

At the beginning of this text, the author
writes that his treatise on the vices is a
continuation of his work on the virtues.
For the frontispiece to the manuscript,
an astonishing variety of animals has
been incorporated into the border, some
of which can be connected with vices,
and others with virtues. The roundels in
the background of the main image,
composed of heraldic eagles and
rampant lions, are similar in form to
the roundels in the borders, suggesting
that the heraldic associations of each
animal should be carefully considered by
the reader.

43 ▷

Eitelfriedrich I Hohenzollern
Chronicle of the Counts of Zollern
Augsburg and Rotterdam, ca. 1572
JPGM, Ms. Ludwig XIII 11, fol. 18

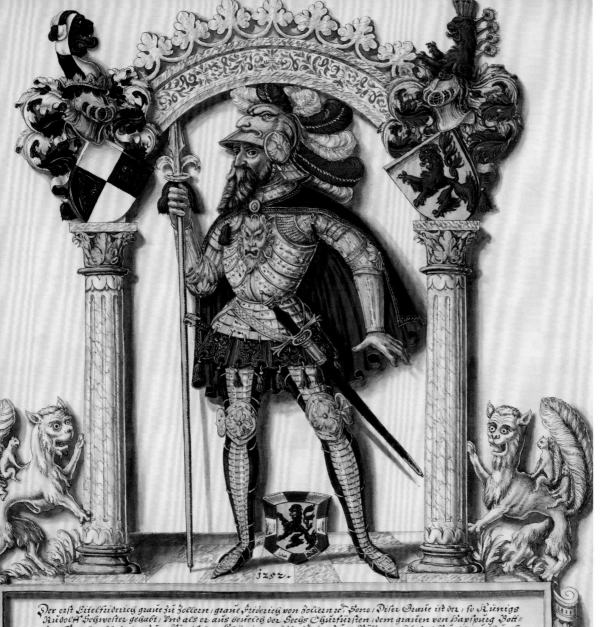

1527.

Der erst Eitelfriderich graue zu Zollern / graue Friderich von zollern etc. Sone / Diser Graue ist der / so Künigs
Rudolfs Schwester gehabt / Vnd als er aus gewesen der Sechs Churfürsten / dem grauen von Hapspurg Gott
schafft gebracht / das er zum Römischen Khünig erwölt / hat er zum Bötten prott / das Burggraffthumb
Nürmberg / oisem seinem Schwager graue Eitelfriderich geschenckht vnd eingeant wirt / Was nun diser
Graue / für ein ansehenlicher weisegraue gewest / gibt Jme desß sach / vnd anndeers nichts / so von Jme geschriben /
am herrliche ansehenliche Zeügnuß / Diser Burggraue hat Fünff Söhn / vnd drey Töchtern / verlassen /
Der ain ist Fürst vnd Burggraue zu Nürmberg bliben / Friderich genant / vnd sich nit mehr Graue zu Zoll-
leren geschriben / Daheer die Marggrauen von Brandenbürg khommen /
Der Annder Eitelfriderich gnant / Ist Graue zu Zollern / geeliben / vnd Khinder verlassen /
Graue Johann / was ain Thümbherr /
Rudolf / hat ain Freiin von Reinegkh /
Albrecht / ist ledig gestorben /
Sorgia / hat ain Marggrauen von Krayöüng gehabt /
Otilia / hat ain Grauen von Fültz gehabt /
Anna / ist ain Closter fraw zu Stetten gewest /

Sein gemahel Martha
Lamböt Freÿin zue
Hapspurg /

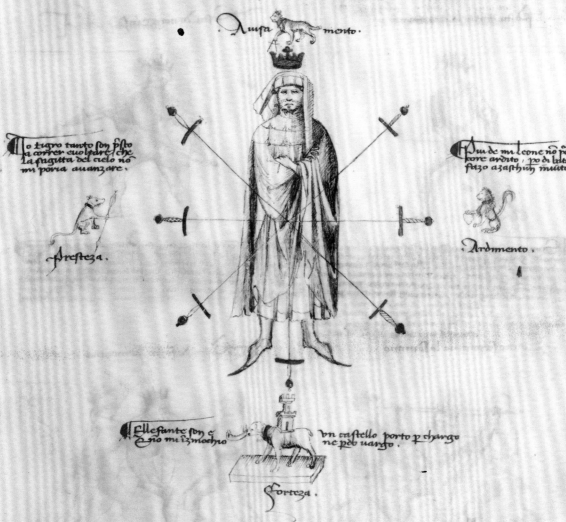

44 △

Aiming Points on the Body

Fiore Furlan dei Liberi da Premariacco,
The Flower of Battle
Probably Venice or Padua, ca. 1410
JPGM, Ms. Ludwig XV 13, fol. 32

Animals commonly associated with a specific heraldic meaning could also serve in other contexts. In this medieval guide to warfare, four animals surround a fencing master and exemplify his qualities. The keen-eyed lynx (top) holds a measuring device, implying that a warrior must be a good judge of distance between himself and his foe. The proud lion (right) places his paw on a heart, as wholehearted dedication to the fight is a necessity. The athletic tiger (left) grasps an arrow, indicating that one must be able to move as fast as an arrow in flight. The elephant (bottom) carries a castlelike structure for soldiers, suggesting that a combatant's stance must be strong and balanced.

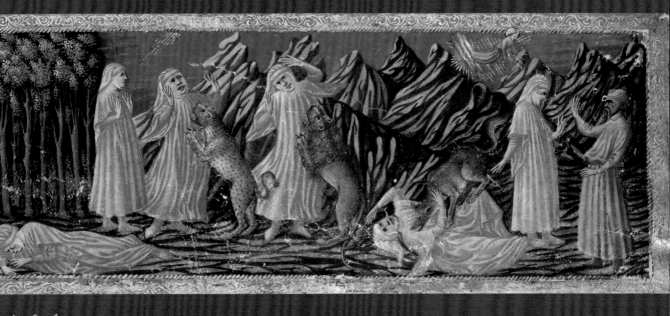

TALES, PARABLES, AND FABLES

Just as George Orwell's *Animal Farm* satirizes human society for modern audiences, or the bedtime story of the *Three Little Pigs* teaches a moral to children, people of the Middle Ages learned about themselves from stories in which animals took a leading role. The Bible is filled with tales where animals fulfill an important symbolic function (figs. 46, 50), and medieval literature abounds with creatures who help or hinder the people they encounter (fig. 45). Whole cultures made up of animals were invented, including one with the full trappings of a medieval court (fig. 48). Aesop's *Fables*, vastly popular in the Middle Ages and still taught in schools today, were short stories in which the humanlike dialogue and thoughts of various animals revealed practical or ethical lessons (fig. 49). All these types of stories used animal characters as symbols of human behaviors and actions—either those to imitate or to avoid. The substitution of animals for humans often made the messages in the stories more palatable or, at the very least, more entertaining.

45 △

Dante Attacked by Animals
Priamo della Quercia
Dante Alighieri, *The Divine Comedy*
Tuscany, 1442–50
BL, Yates Thompson Ms. 36, fol. 2

In perhaps the most famous work of literature written during the Middle Ages, *The Divine Comedy*, the author Dante tells of a vision where he travels through the realms of hell, purgatory, and heaven. Upon arriving in the dark wood of hell, he is immediately attacked by three wild beasts. Each represents a different sin: the leopard is lust; the lion, pride; and the she-wolf, greed. Dante's increasing fear and helplessness are captured in this miniature, where he is eventually thrown to the ground and violently set upon by the she-wolf. Each attack makes Dante realize how he has strayed from the true path into sin.

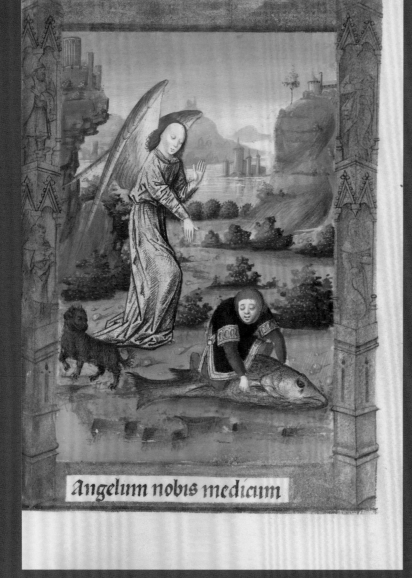

Angelum nobis medicum

46
Tobias and the Angel
Master of Guillaume Lambert
Book of hours
Lyons, 1478
JPGM, Ms. 10, fol. 186

According to this biblical story, Tobias went out to seek help for his blind father, accompanied by a hired companion who turned out to be the archangel Gabriel. While Tobias was washing his feet one morning, a monstrous fish emerged from the depths of the water. Tobias was terrified, but the angel advised him to take the fish and cut out its entrails, which miraculously cured his father's blindness. The great size of the fish seems almost to overwhelm the figure of Tobias in this image, but faith in the angel's words makes him willing to confront the enormous creature.

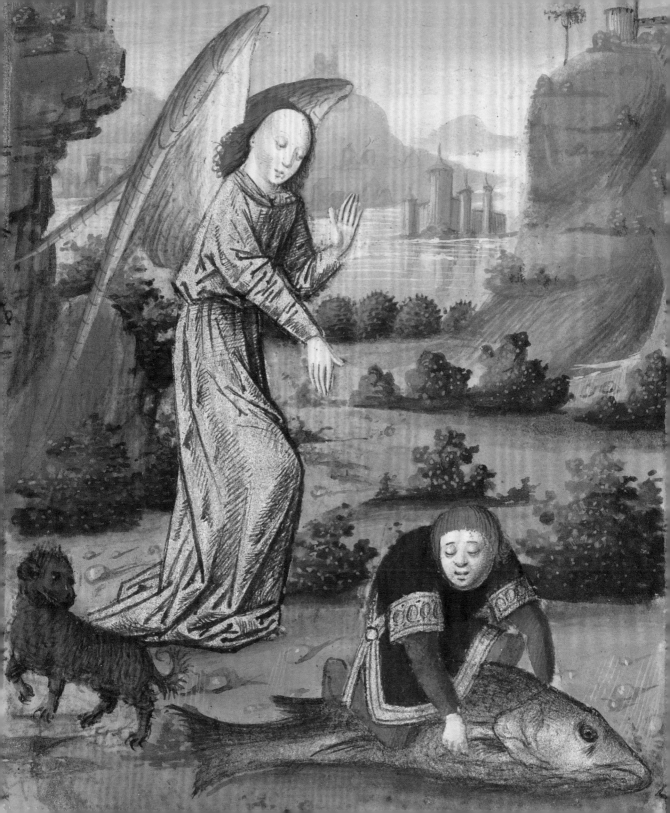

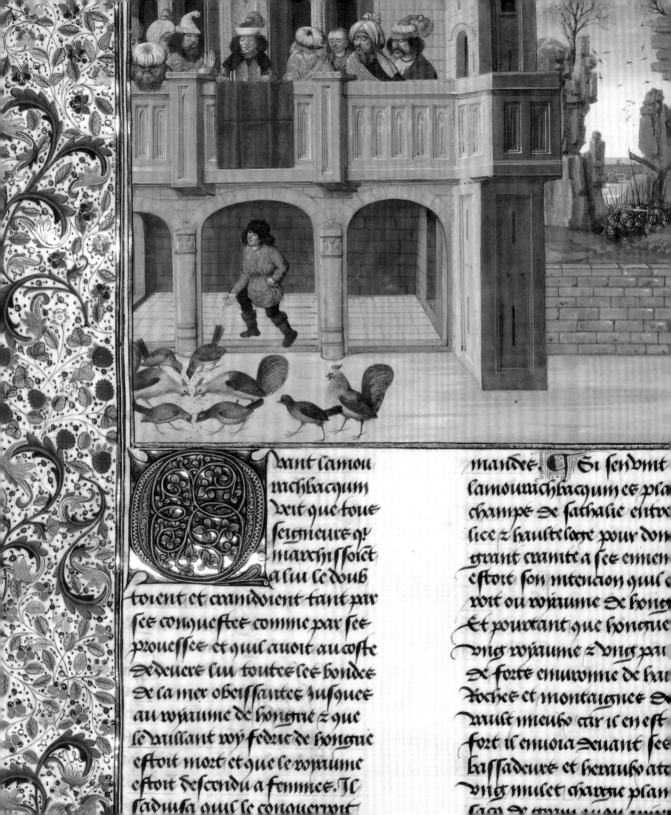

[Q]uant lamou
richbacquin
veit que tout
ſeigneurs qͥ
marchiſſoiet
a lui ſe doub
toient et craindoient tant par
ſes conqueſtes comme par ſes
proueſſes et gͥl auoit au coſte
dedeuers lui toutes ſes bondes
de la mer obeiſſantes iuſques
au royaume de hongrie z que
le vaillant roy fedric de hongrie
eſtoit mort et que le royaume
eſtoit deſcendu a femmes. Il
ſaduiſa qͥl le conquerroit

mandee. Si ſenuint
lamourichbacquin eſ pla
champs de ſathalie entre
lice z haulte ſoite pour don
grant crainte a ſes ennem
eſtoit ſon intencion qͥl c
roit ou royaume de hon
Et pourtant que honorͥe
vng royaume z vng pai
de forte enuironne de hau
roches et montaignes d
vault meubo car il en eſt
fort il enuoia deuant ſe
baſſadeurs et herauso at
vng mulet chawͥe plan

47 ◁

The Parable of the Hens and the Corn

Master of the Getty Froissart

Jean Froissart, *Chronicles*

Bruges, ca. 1480

JPGM, Ms. Ludwig XIII 7, fol. 83v

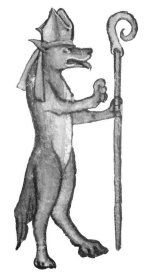

Jean Froissart was known for his colorful tales about the Hundred Years' War (1337–1453), exemplified by this parable. The ambassador of the Turks, holding up a bag, threatened the king of Hungary with as many invading Turks as there were grains in the bag unless he surrendered. The king promised a reply in three days, during which time he locked up 10,000 head of poultry without food. When the Turkish ambassador returned for his answer, the king released the chickens and threw the contents of the bag to them, declaring that the Hungarian forces would destroy the Turks like the birds devouring the grain.

48 ▽

Border with Reynard the Fox

Smithfield Decretals

France?, ca. 1300–1340

BL, Royal Ms. 10 E.IV, fol. 49v

The medieval tale of Reynard the Fox was the first work of the Middle Ages in which the story was completely filled with animal characters mimicking human society. Reynard is a wily fox who can seemingly smooth-talk his way out of any difficulty. The other members of the court, including Bruin the Bear, Baldwin the Ass, and Tibert the Cat, are driven to complain about him to King Noble, a lion. Time and again, however, Reynard escapes punishment to commit more tricks, as in this image where he dresses himself up as a bishop and preaches to a flock of birds.

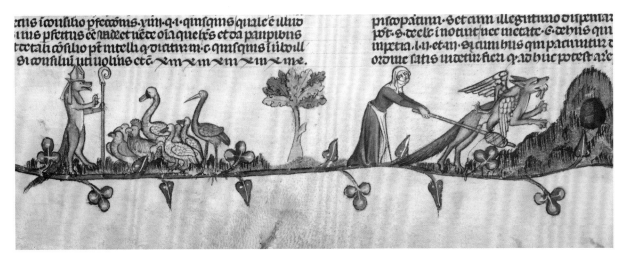

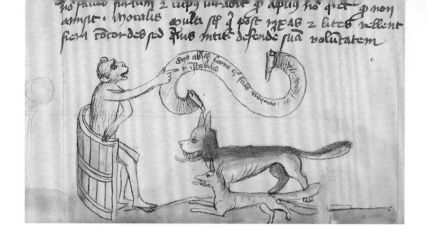

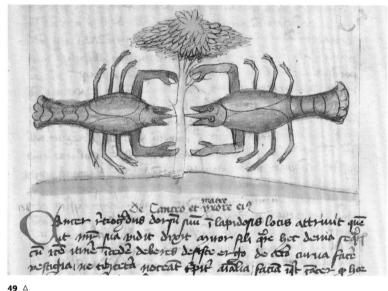

49 △

A Monkey Instructing a Fox and a Wolf;
A Crab and Its Mother
Aesop, *Fables*
Probably Trier, ca. 1450–75
JPGM, Ms. Ludwig XV 1, fols. 48v (top), 49 (bottom)

50 ▷

Christ and a Monk and Two Shepherds
Hugo de Fouilloy, *Treatise on Shepherds and Flocks*
Thérouanne?, ca. 1270
JPGM, Ms. Ludwig XV 3, fol. 46v

At the top of this miniature, Christ shares his role as good shepherd with a monk, to whom he hands a crosier (a symbol of religious authority shaped like a shepherd's crook). Reflecting the qualities of a good and bad shepherd of men, a keeper and his watchful dog (below on the left) actively look after a flock of complacent sheep, while a snoozing warden and his inattentive dog (on the right) fail in their duties to a tribe of goats. The use of the two types of animals is based on the Bible's parable of the separation of the sheep (the blessed) from the goats (the accursed).

Once a very large wolf who was revered by his peers as large enough to be a lion left his pack to go live with the lions. A sly fox, seeing this, told the wolf that although his vanity might convince him he was something else, he would always be nothing more than a wolf among lions. Similarly, one day a mother crab criticized her child for not walking in a straight line, but when he meekly asked her to show him how and she promptly scuttled sideways, she ceased to censure him. In both these fables, the illuminator has taken artistic liberty to make the fables more lively, in one case adding a preaching monkey and in the other making the crabs appear as a pair of ponderous lobsters.

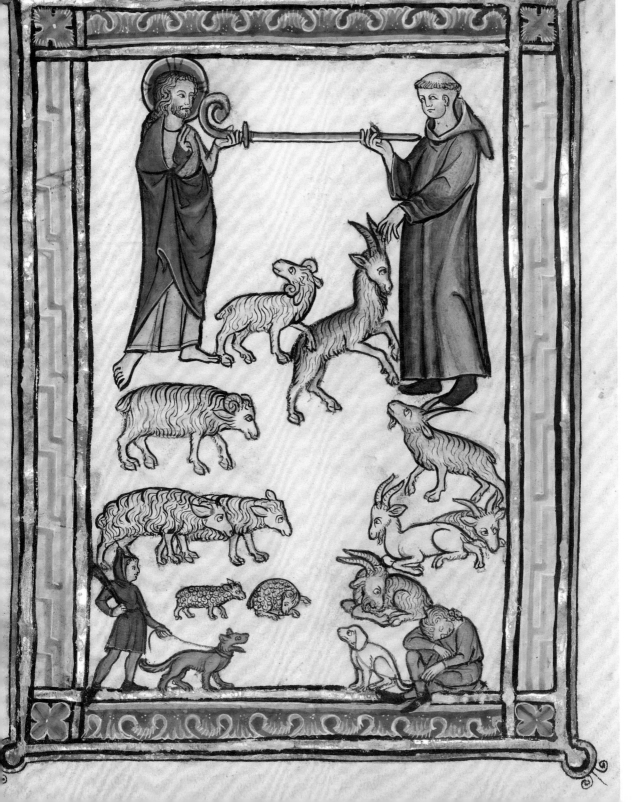

BEASTS IN FOCUS: THE BESTIARY

The bestiary, or "book of beasts," was a collection of stories about creatures both real and fanciful in which the characteristics seen as typical of a particular animal were ascribed moral or Christian meaning. For instance, the caladrius bird was thought to instinctually take on the sickness of those worthy of saving, just as Christ took on the sins of those destined for heaven. Natural phenomena were therefore explained as purposeful reflections of the divine. The sheer variety of animal life described in bestiaries ensured that the artists illuminating them very often had never seen the actual animals they were painting, so they used either their imagination or written and oral descriptions to formulate an animal's appearance. The results can sometimes be surprising or even amusing.

Bestiary

Thérouanne?, ca. 1270

JPGM, Ms. Ludwig XV 3

51 ◁

An Eagle Flying above Water, fol. 43v

When the eagle grows old its wings grow heavy, and its eyes grow dim. Then it seeks out a spring and, turning away from it, flies up into the atmosphere of the sun; there it sets its wings alight and, likewise, burns off the dimness in its eyes in the sun's rays. Descending at length, it immerses itself in the spring three times; immediately it is restored to the full strength of its wings, the former brightness of its eyes. In the same way, you, O man, with your old clothes and dim eyes, should seek the spiritual spring of the Lord.

52 ▷

Two Lions, fol. 68

Those who study nature say that . . . when a lioness gives birth to her cubs, she produces them dead and watches over them for three days, until their father comes on the third day and breathes into their faces and restores them to life. Thus the Almighty Father awakened our Lord Jesus Christ from the dead on the third day.

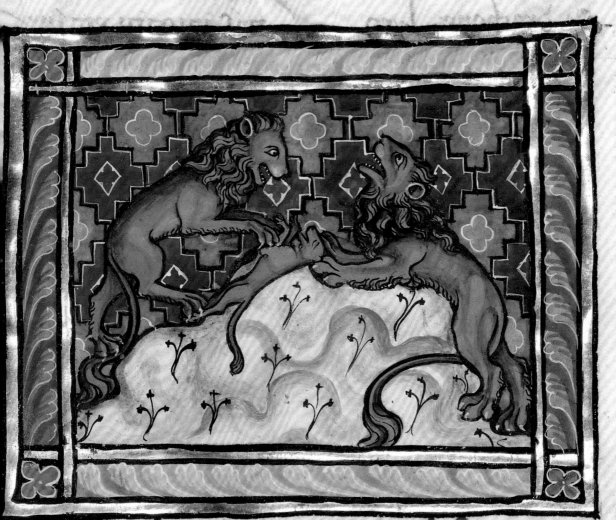

Bestiarū uocabu
lum ꝑꝑe ꜹenit
leconibʒ. pardiſ. tygri
bʒ. lupiſ. uulpibʒ. et
tẏniſ. urſiſ. ⁊ ꝯciſ.
q̇ uel oꝛe uel ungu̇ibʒ
ſeu̇iu̇nt. exceptiſ ſer
pentibʒ. Beſtie au

berant͛. Sunt cu̇m
libero coꝛ uolū̇tateſ.
⁊ huc atqʒ illuc ua
gant͛. ⁊ quo anū̇i
duxerit feruntur.
Leconiſ uocabulū̇ �...
grēca oꝛigine in
flꝯxū̇ ⁊ in latinū̇.

53 ◁

A Hunter Pursuing a Beaver, fol. 83

*There is an animal called the beaver,
which is extremely gentle; its testicles
are highly suitable for medicine. When
it knows that a hunter is pursuing it, it
bites off its testicles and throws them in
the hunter's face and, taking flight,
escapesThus every man who heeds
God's commandment and wishes to live
chastely should cut off all his vices and
shameless acts, and cast them from him
into the face of the devil.*

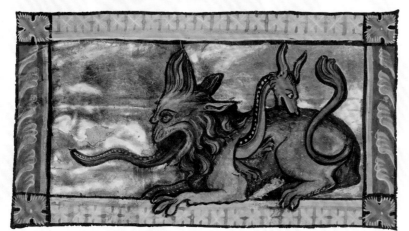

54 ◁

A Crocodile and a Hydrus, fol. 84v

*The [hy]drus is a worthy enemy of the
crocodile and has this characteristic and
habit: when it sees a crocodile sleeping
on the shore, it enters the crocodile
through its open mouth, rolling itself in
mud in order to slide more easily down
its throat. The crocodile therefore,
instantly swallows the [hy]drus alive.
But the [hy]drus, tearing open the
crocodile's intestines, comes out whole
and unharmed. For this reason death
and hell are symbolized by the crocodile;
their enemy is our Lord Jesus Christ.
For taking human flesh, he descended
into hell and, tearing open its inner
parts, he led forth those who were
unjustly held there.*

55 ▷

A Monkey, fol. 86v

They are called monkeys (simia) in the Latin language because people notice a great similitude to human reason in them. Wise in the lore of the elements, these creatures grow merry at the time of the new moon A monkey has no tail (cauda). The Devil resembles these beasts; for he has a head, but no scripture (caudex).

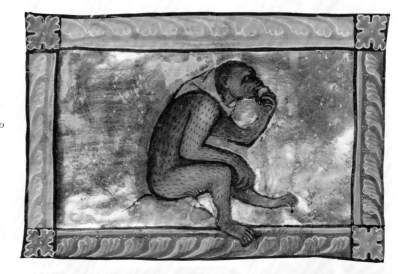

56 ▷

Two Fisherman on a Sea Creature, fol. 89v

This animal lifts its back out of the open sea above the watery waves, and then it anchors itself in the one place. . . . Sailing ships that happen to be going that way take it to be an island, and land on it. Then they make themselves a fireplace, but the whale, feeling the hotness of the fire, suddenly plunges down into the depths of the deep, and pulls down the anchored ship with it into the profound. Now this is just the way in which unbelievers get paid out, the people who are ignorant of the wiles of the Devil. . . . They anchor themselves to him, and down they go into the fires of hell.

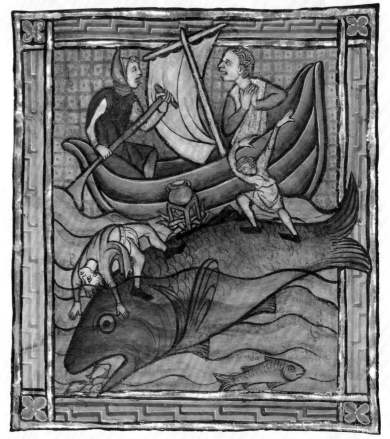

FANTASTIC BEASTS

What is the point of those unclean apes, fierce lions, monstrous centaurs, half-men, striped tigers, fighting soldiers and hunters blowing their horns? In one place you see many bodies under a single head, in another several heads on a single body. Here on a quadruped we see the tail of a serpent. Over there on a fish we see the head of a quadruped . . . Good Lord! If we aren't embarrassed by the silliness of it all, shouldn't we at least be disgusted by the expense?

BERNARD OF CLAIRVAUX, TWELFTH CENTURY

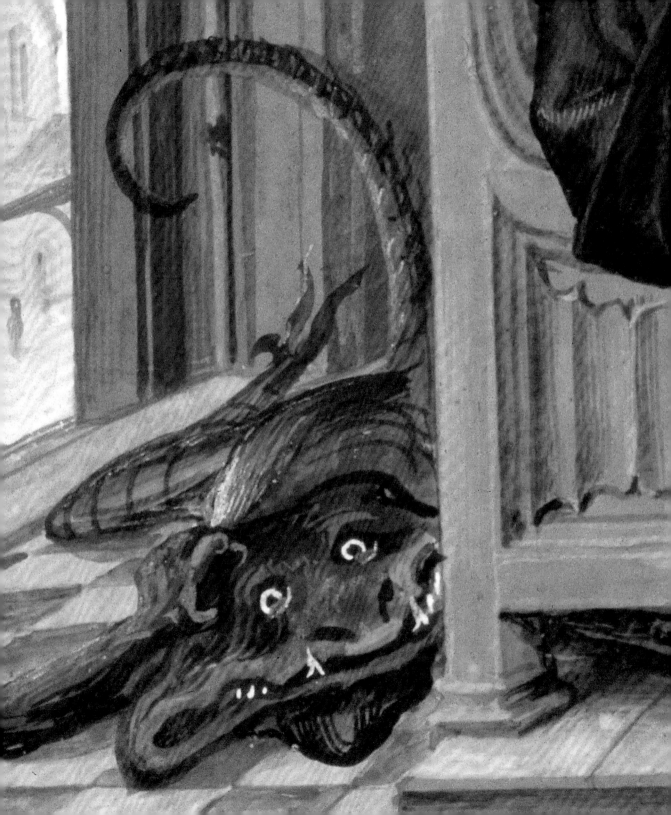

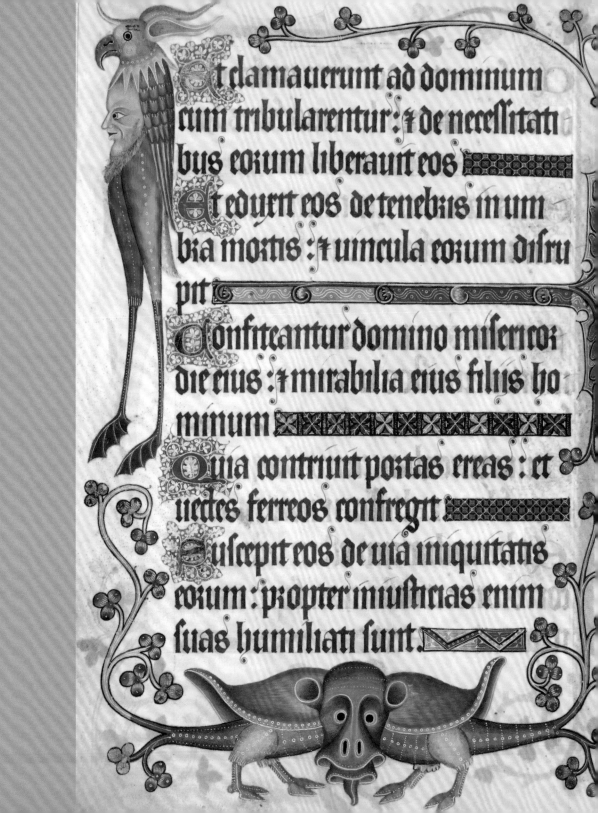

57 ◁

Marginal Hybrids

Luttrell Psalter

England, ca. 1325–35

BL, Add. Ms. 42130, fol. 195v

58 ▽

Marginal Creature

Leaf from *The Life of Apa Samuel*

Coptic, 900s

JPGM, Ms. 12, recto

MARGINAL HYBRIDS

The creatures that inhabit the margins of medieval manuscripts are among the most amusing and charming creations of the Middle Ages. They are often referred to as "hybrids" because they appear to have the features of two, three, or even more different kinds of animals. A human head perches on top of bird legs (fig. 57), a man holding a shield and sword has a surprisingly lionlike body (fig. 62), and a knight with webbed feet rides on an animal whose antecedents can only be guessed at (fig. 60). These marginal creatures are often completely unrelated to the main, more serious scene on the page and frequently appear as comical characters playing merry tricks in the borders—fighting mock battles or performing impromptu concerts on musical instruments. These figures not only appear in manuscripts but also can be found sculpted in stone, carved in wooden choir stalls, or mischievously peeking out from stained-glass windows, in such profusion that Saint Bernard of Clairvaux, a Cistercian monk, was moved to eloquently denounce them as troubling and even obscene distractions (see quote on p. 68).

de sacro scis ecclijs ī earū
dem ministris. Cōes. De las
scās eglesias ī delos sus sier
uos et ministros.

E el
nom
pne
del nu
estro
seyn
nor
xhū
xpo.
Qui
es comencamiento. ī nasci
miento et fin de todas las
cosas. En el comienço de
la nīa obra con deuotion
ordenamos. Que en hōdra
de dios todas las egl'ias sea
temidas ī hōdradas de todos
los oīs. Hungū ome de qual
quiera o dicōn eill sea. que

grada no es. peyte. lē. s
por qual quiera delas
as uioladas. peite el hō
dio segūt costumpne d
qillos logares. De eod
hondra daqill qui
xo en el psalmo p
ca de dauid ppha
grades nozer. a los mus
er assabz los pstres ī las
as psonas eccliasticas
a seruicō de dios. ī no qi
ser maldignos otra las
pphetas ni otraniar a eill
con humildat ī deuotiō
dius. Establesceimos ī o
namos q qin ferieit o n
re subdiachono o diac
q peite. dcc. ss. si cappe
no. dcccc. ss. rebus qin
ecclam qfugiunt. Co
delos qui fuyen ala egl
o al palacio por ser desi

59 ◁
Initial E: A Priest Celebrating Mass
Feudal Customs of Aragon
Northeastern Spain, ca. 1290–1310
JPGM, Ms. Ludwig XIV 6, fol. 9

▷
Initial C: Two Attorneys and Clients before a Judge
Feudal Customs of Aragon
JPGM, Ms. Ludwig XIV 6, fol. 95v

FANTASTIC BEASTS | HYBRIDS

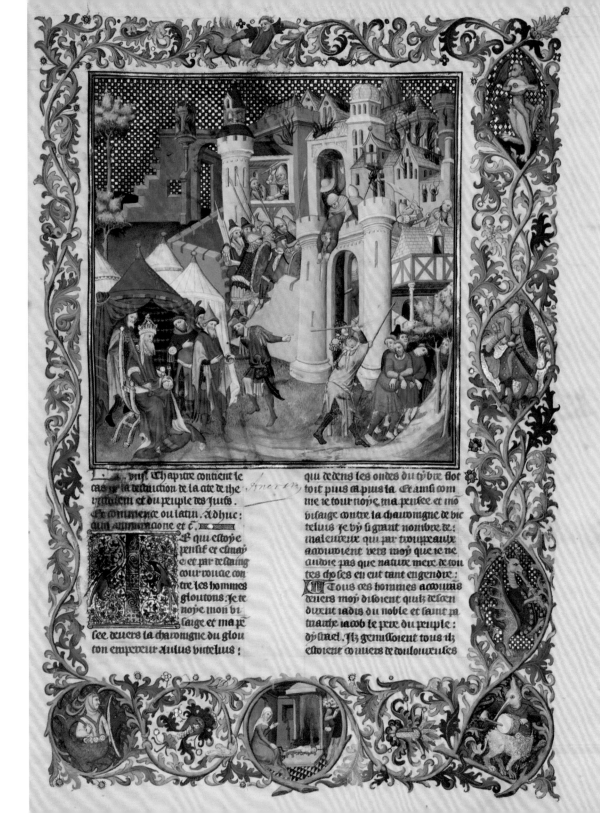

60

The Destruction of Jerusalem (with Border Hybrids)

Boccaccio, *Concerning the Fates of Illustrious Men and Women*

Paris, ca. 1415

JPGM, Ms. 63, fol. 237

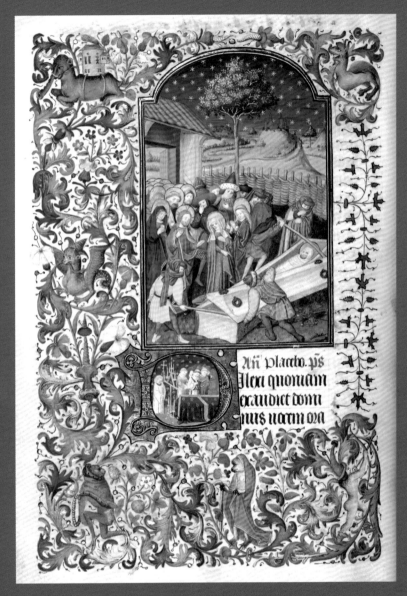

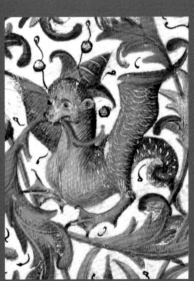

61 △

The Raising of Lazarus (with Marginal Hybrids)
Saluces Hours
Savoy, mid-1400s
BL, Add. Ms. 27697, fol. 118v

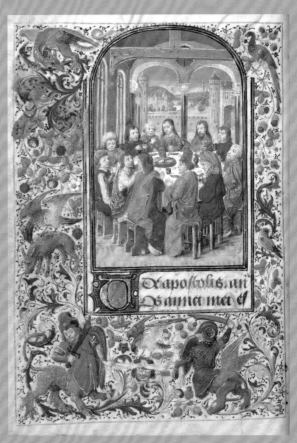

62 ▷

The Last Supper (with Marginal Hybrids)
Prayer Book of Charles the Bold
Ghent and Antwerp, ca. 1471
JPGM, Ms. 37, fol. 23v

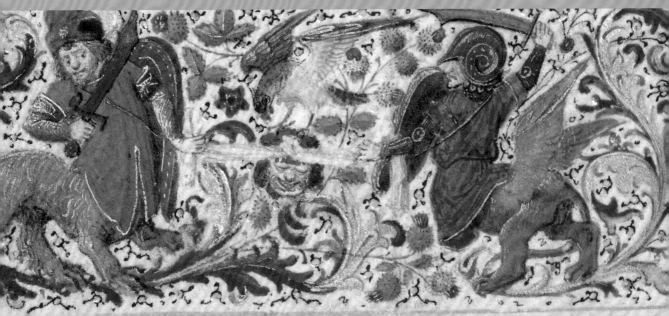

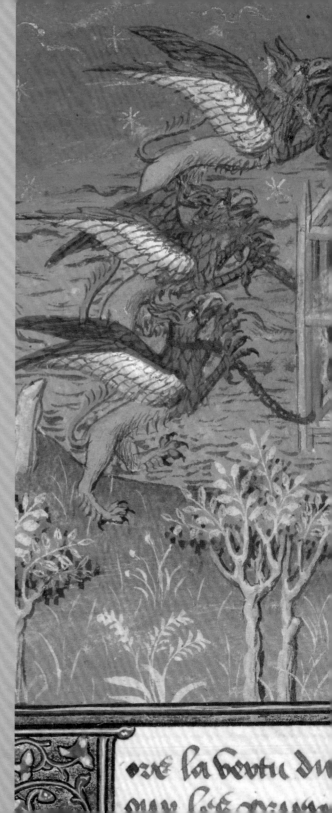

MYTHOLOGICAL ANIMALS

The legendary tales of ancient Greece and Rome were inherited by readers in the Middle Ages who were fascinated by accounts of the mythological beasts that tormented the heroes of yore. In medieval texts, the voyages of unsuspecting sailors were threatened by the terrifying multiheaded female sea monster called Scylla (fig. 65), and the wild energy of the dreaded griffins was harnessed by Alexander the Great to propel his dreams of flying (fig. 63). Many mythological animals, including unicorns (fig. 67), centaurs (figs. 64, 66), and sirens (figs. 65, 66), among others, were described in great detail as real creatures in bestiaries, natural histories, and travelogues. They took their place in the medieval imagination next to the likes of elephants, leopards, and monkeys as animals that inhabited the lands beyond Europe at the farther reaches of the earth.

63

Alexander Carried by Griffins

Alexander Romance

France, early 1400s

BL, Royal Ms. 20 B.XX, fol. 76v

According to legend, Alexander the Great was curious about the heavens above the earth, so he constructed a machine for ascending into the air. The vehicle was a leather basket drawn by griffins (creatures combining the features of an eagle and a lion), who were lured into continuing their ascent by meat held above them on a stick.

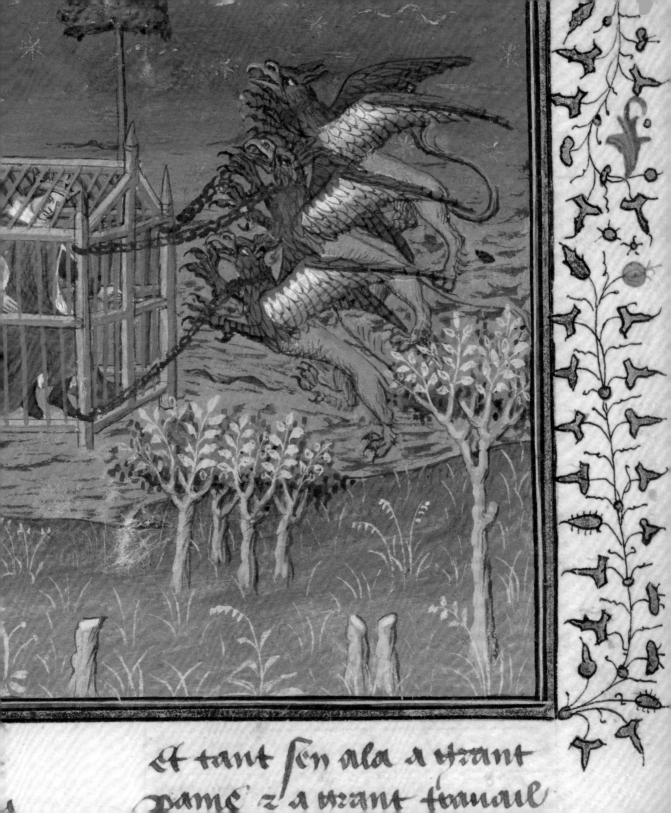

Et tant sen ala a grant
vame z a grant travail

meulz garde et ſeruu ſon mari ſi ne ſeu pouo eſtre arſe auec ſon mari. et

nporte teſloier. que par ſe Jugemet les aultres ſen vont la ou eſtes veulent.

v parle de aultres manieres de ſeue transfigurez. xij.xx.xim.

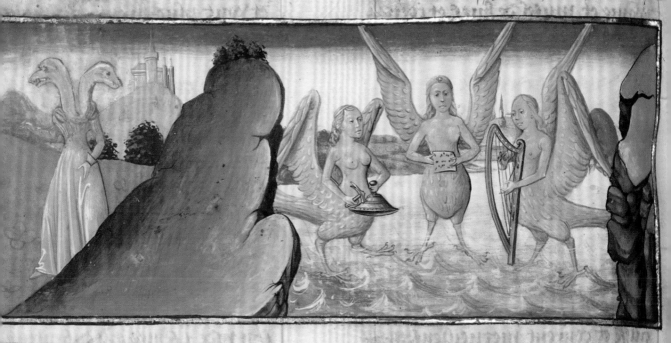

en raconte en aucunes ſa voir. et faiſoient perir les nautonier

fables de aucuns qui en la mer. Mais a la reale verite ce furet

ſont faus par Interpre troie folce femes qui menoient les

tation Auſſi come de Seuon roy deſpu hornes qui les hantoient a ſi grant

64 ◁

Inhabited Initial H with a Centaur

Gratian, *Decretals*

Paris or Sens, ca. 1170–80

JPGM, Ms. Ludwig XIV 2, fol. 8v

65 △

Scylla and Sirens

Vincent of Beauvais, *Mirror of History*

Ghent, ca. 1475

JPGM, Ms. Ludwig XIII 5, vol. 1, fol. 68v

The sea monster Scylla was described in antiquity as having twelve feet and six heads, each featuring three rows of sharp teeth. The medieval version of Scylla is rather different, looking quite attractive (and human) from the neck down, and limiting her deformities to two dragonlike heads. The sirens, on the other hand, are quite normal from the waist up but feature chicken legs and huge wings below. Both types of female creatures were meant to serve as metaphors for the fact that women can appear beautiful and enticing but at the same time flaunt a beastly nature.

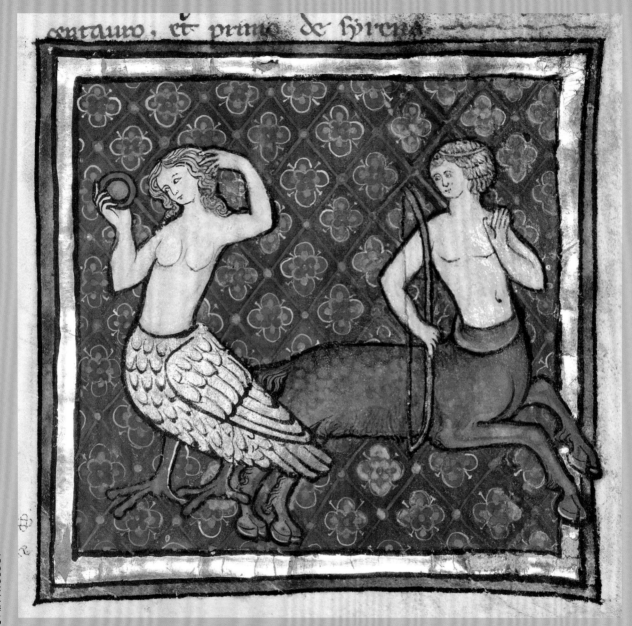

66 △

A Siren and a Centaur

Bestiary

Thérouanne?, ca. 1270

JPGM, Ms. Ludwig XV 3, fol. 78

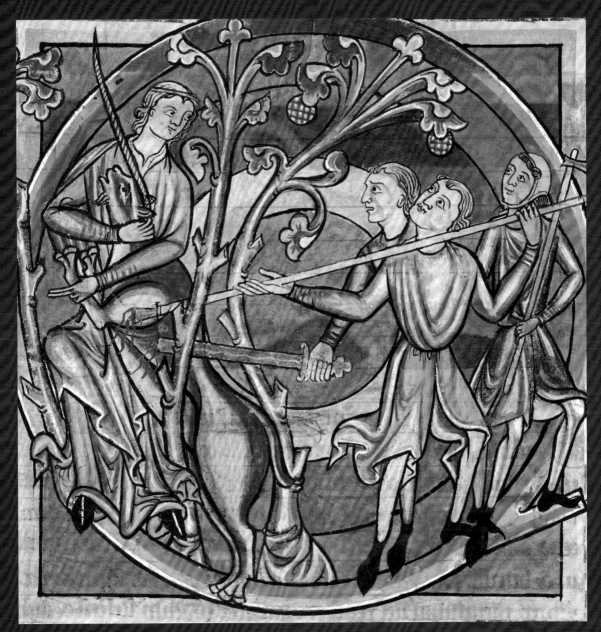

67 △

A Unicorn Enticed by a Virgin
Bestiary
Salisbury?, ca. 1230–40
BL, Harley Ms. 4751, fol. 6v

The major exception to the litany of hostile beasts that inhabited mythological texts was the unicorn, which was seen in the Middle Ages as a noble figure of purity and moral strength, even a symbol of Christ. As seen here, the unicorn could only be captured by an untouched virgin, who would lull the creature to sleep so that hunters could seize it.

Even now the idea of humans morphing into animals is an intrinsically frightening idea, as evidenced by horror movies where ghastly experiments lead to monstrous half-humans / half-beasts who inherit the base appetites of wild animals and lose all sense of reason. In the Middle Ages, however, before modern biology revealed that humans are simply the most highly developed animal species, the divide between human and animal was even vaster, and the idea of any crossover at all was abhorrent. According to medieval belief, the outward adoption of an animal form implied the loss of a human soul or, worse, the possibility that the devil himself would take on a partly human form to lead the faithful astray. From tales of saints tempted by the devil in human form (fig. 68), to stories of the smooth-talking serpent who deceives Eve (fig. 70), to descriptions of bizarre humanlike creatures beyond the lands of Europe (fig. 71), those in the Middle Ages were at once repelled and fascinated by the idea of the shift from human to animal and what the blurring of species could mean in terms of bestial passions invading the human realm.

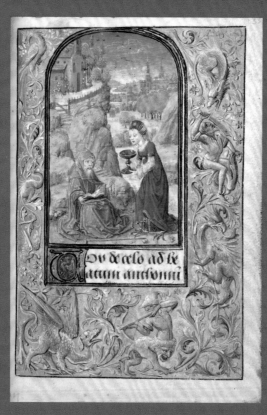

68

The Temptation of Saint Anthony

Lieven van Lathem

Prayer Book of Charles the Bold

Ghent and Antwerp, 1469

JPGM, Ms. 37, fol. 33

The lively story of the temptation of Saint Anthony, a fourth-century hermit who lived alone in the Egyptian desert, was widely known during the Middle Ages. This artist's depiction, based on legend, shows Saint Anthony being tempted into the sin of fornication by a beautiful young woman dressed at the height of fashion. The fact that she is really the devil in disguise, however, is revealed by the beastly claws that can just be seen peeping out from under her robe.

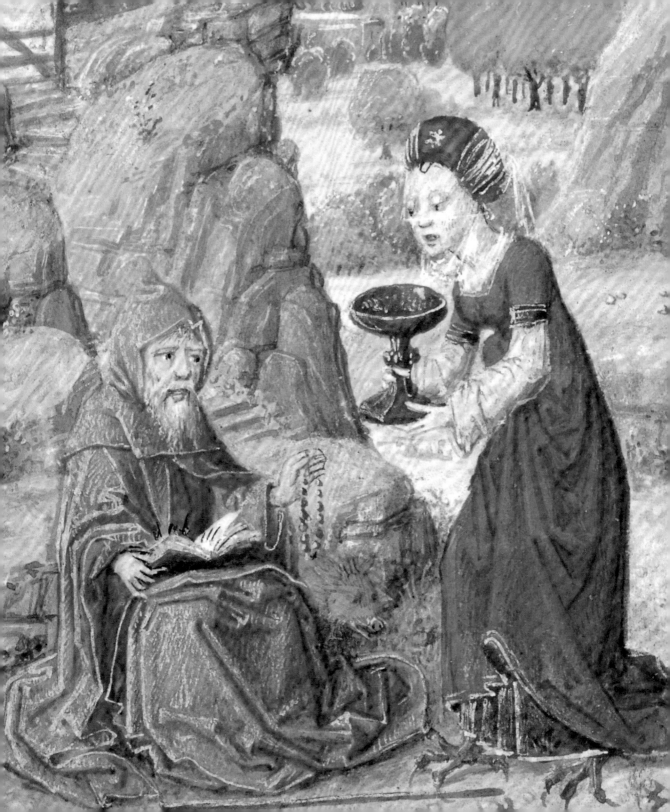

So sind ewe sinn under chomen
Und vart gewaltichleich

und warff er dar inn
Do lextu in sein sinn

69 △

Nebuchadnezzar as a Wild Animal
Rudolf von Ems, *World Chronicle*
Regensburg, ca. 1400–1410
JPGM, Ms. 33, fol. 215v

According to the Bible, one day as Nebuchadnezzar, king of mighty Babylon, walked on the roof of his castle, wondering at his own power and glory, God came to him, took away his kingdom, and condemned him to live in the woods like an animal. During that time, hair grew all over his body, his nails grew like claws, and he was forced to live alone without society and the ability to think. At the end of seven years, he raised his eyes to heaven, and reason returned to him so that he could praise and honor God as the only true sovereign.

The Temptation
Master of the David Scenes in the Grimani Breviary
Hours of Joanna the Mad
Bruges, between 1496 and 1506
BL, Add. Ms. 18852, fol. 14v

By the later Middle Ages, it was common to show the serpent in the Garden of Eden as having a female head, a reference both to the perception that it was Eve, a woman, who led Adam astray and to the commonly held medieval belief that women were a slightly lesser species of human with a more bestial, sensual nature than men.

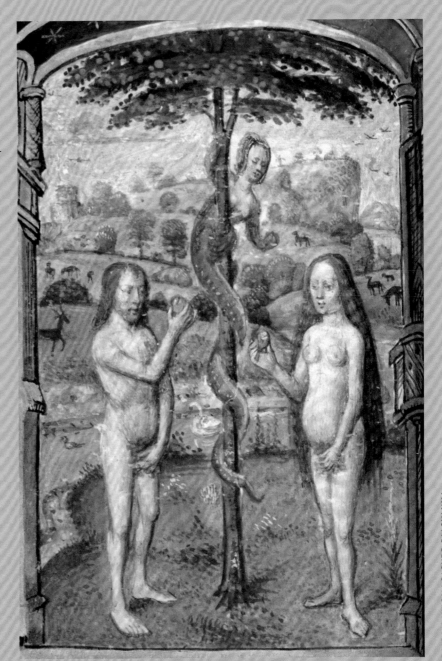

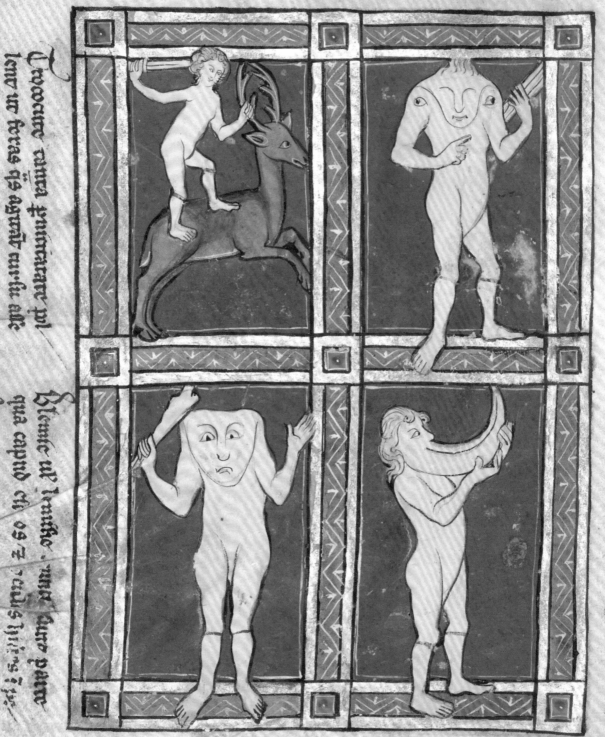

Gens sm euctibz octōs hūs t hūneros.

Gens ē alio pmineat vnde nōr facien̄
conteram folis arboꝝ vegunt.

Crocodꝛ cōtra pᵹmitatem pꝉ
leuꝰ ut feras q̄ agrint aᵭrtu ille
auertuꝛ.

Blemē ut blembꝰ uᵭ auᵭe paret
q̄ capud cū os t oculis hꝰ ī pec
tore.

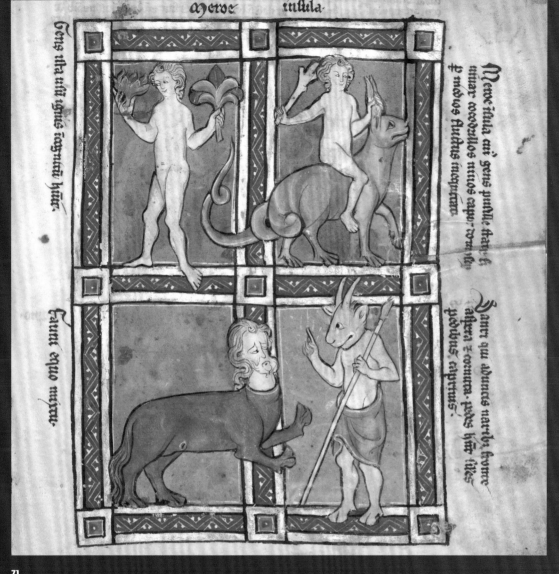

71
Creatures from the Ends of the Earth
Wonders of the World
Thérouanne?, ca. 1277
JPGM, Ms. Ludwig XV 4, fols. 117v (left), 119 (above)

Stories of the creatures that lived at the ends of the earth were immensely popular during the Middle Ages. Tales of men with eyes on their shoulders, heads in their chests, or vastly oversized lower lips vied with accounts of those who still had no knowledge of fire or who traveled only by means of riding on wild beasts. They were considered by most as real phenomena, so much so that scholars debated such questions as whether they were created in the Garden of Eden or had immortal souls.

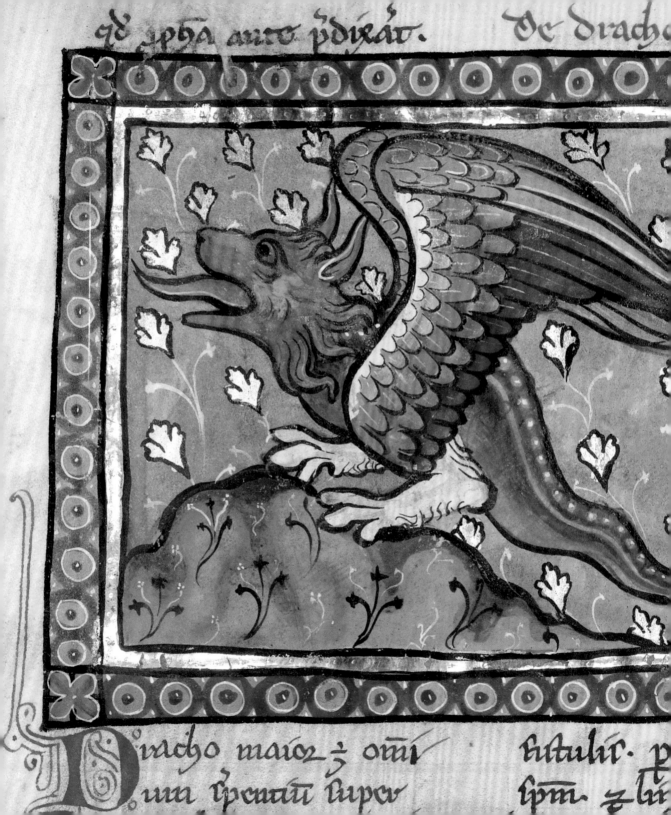

Dracho maior ē omi
uiu spentu super titulr. p
spm. ʒ li

DRAGONS AND DEMONS

Perhaps no other beast evokes in our imagination the romance of the Middle Ages more immediately than the dragon. The story of a knight valiantly defending a beautiful princess before the gates of a fortified castle against the terrors of a great winged monster is a familiar one to us. Dragons and demons were no less prominent in the minds of medieval Christians, who had only to look at their bestiaries for a physical description of the beasts (figs. 72, 73) and to their stories of saints' lives for an account of the threats and deeds perpetrated by these creatures (figs. 75, 76). The Bible itself gives prominent place to dragons and demons, beginning with the sly serpent who goads Eve into eating the forbidden fruit in Eden and ending with the seven-headed dragon who will rule at the end of time during the Apocalypse (fig. 83). Of particular and almost constant concern to medieval Christians were the terrible creatures who eagerly awaited the sinful in the nether regions of the underworld (fig. 77). The depictions of dragons and demons throughout the Middle Ages give us some of the most imaginative images ever created, terrifying and delighting at the same time.

72

A Dragon
Bestiary
Thérouanne?, ca. 1270
JPGM, Ms. Ludwig XV 3, fol. 89

This bestiary describes the dragon as the largest and most fearsome of all of God's creatures, disdaining the power of any other animal. Living in the warm climes of Ethiopia and India, the dragon was known for lurking along paths frequented by elephants. When one would pass by, the dragon would wrap its powerful tail around the animal and squeeze until its victim could no longer breathe.

73 ◁
A Dragon
Bestiary
England, between 1255 and 1265
BL, Harley Ms. 3244, fol. 59

74 ▷
Initial A: Pentecost
Attributed to Stefano da Verona
Cutting from an antiphonal
Lombardy, ca. 1430–35
JPGM, Ms. 95, recto

The dragons whose intertwined necks help form an initial A around this scene of Pentecost look sleepy rather than threatening in their languid poses. Their pastel coloring and otherworldly quality, however, add to the fairy-tale atmosphere of the scene.

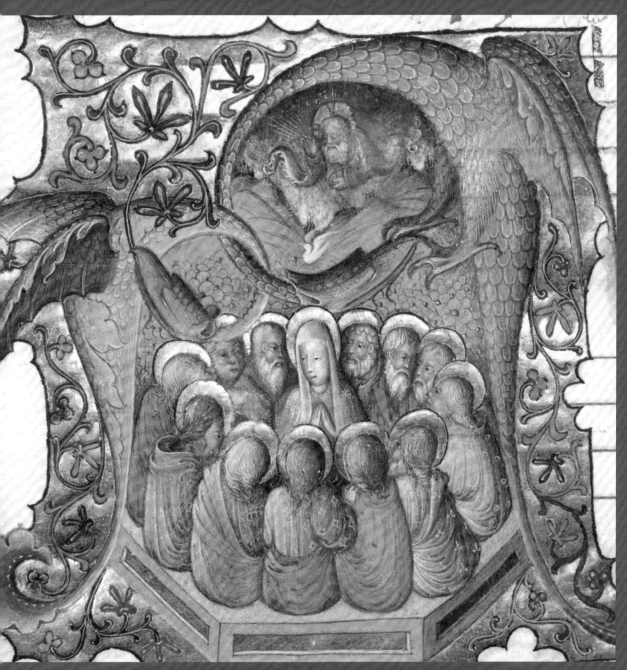

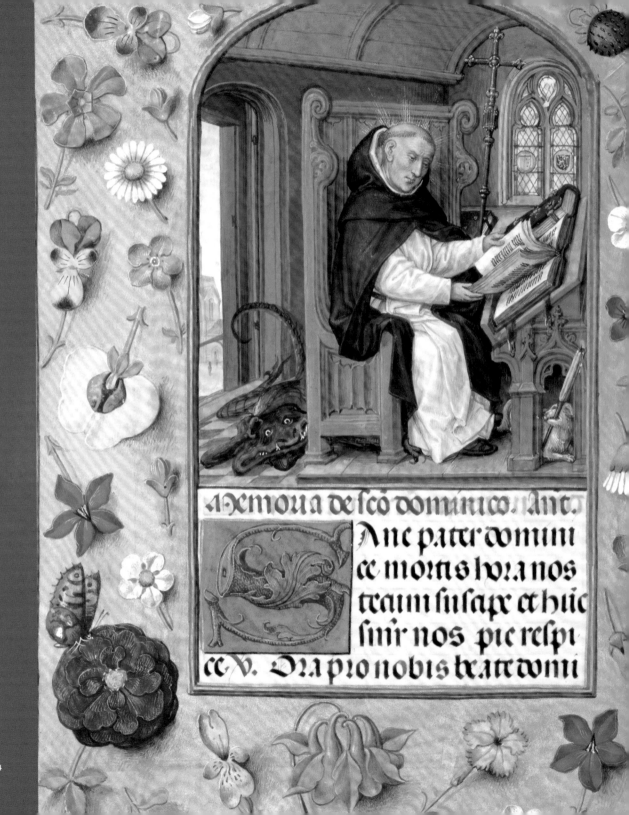

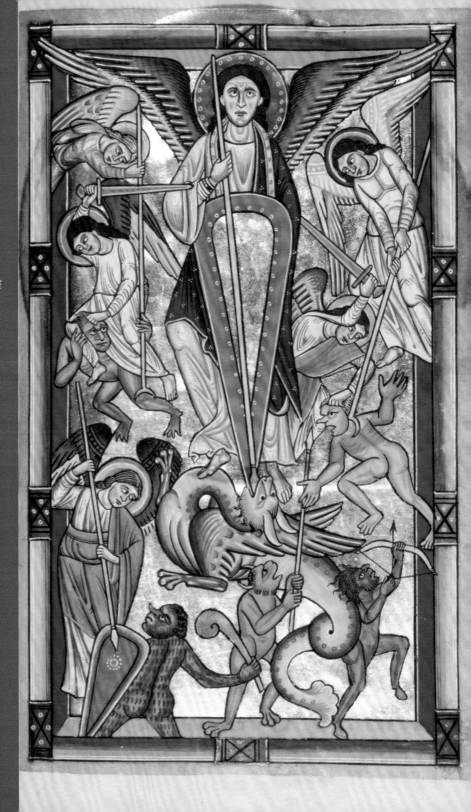

75 ◁

Saint Dominic

Master of James IV of Scotland

Spinola Hours

Bruges and Ghent, ca. 1510–20

JPGM, Ms. Ludwig IX 18, fol. 260v

In this image, while Saint Dominic dili-
gently works on his scholarly tasks at
his desk, a demon slithers across the
floor behind him, threatening his stud-
ies. The frisky white dog under the desk
helpfully holding a light for Dominic is
a reference to a vision his mother had of
her son transformed into a little dog
who would set fire to the whole fabric
of the world with his torch. The demon
represents the devil's attempts to thwart
Saint Dominic's learned preaching and
profound scholarship, while the dog
proclaims the saint's ultimate success.

76 ▷

Saint Michael Battling the Dragon

Stammheim Missal

Hildesheim, ca. 1170s

JPGM, Ms. 64, fol. 152

77

The Torment of Unchaste Priests and Nuns

Simon Marmion

The Visions of the Knight Tondal

Ghent and Valenciennes, 1475

JPGM, Ms. 30, fol. 24v

In the Middle Ages, hell was primarily understood as a place where endless physical tortures were inflicted on the damned by horrific dragons and demons. This image depicts the special agony reserved for unchaste priests and nuns: the beast eats their souls then excretes them onto a lake of ice, where they are reconstituted into human form only to be gobbled up again in an unending cycle of agony.

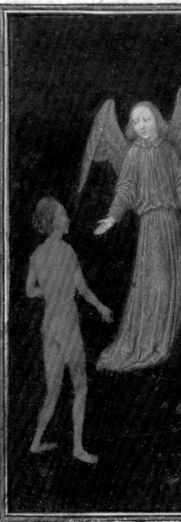

auaone
dist lore-
f deuone

benir a veoir la gloire des
saulues. Je te pue q̃ tãtost
passone oult les tormens

ourmene
uy est-
gieuz
quy ne

et aloir deuant. et la
me du cheuallier apre
si choisirent tantost vne
beste dessemblable et nõ

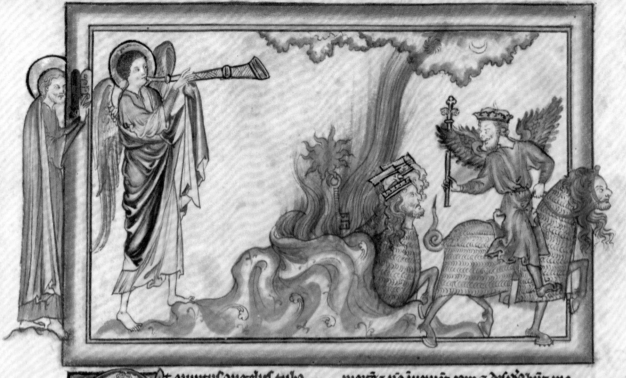

et quintus angelus tuba
cecinit ꝫ uidi stellam de
celo cecidisse in terram ꝫ
data est illi clauis putei

morte ꝫ nō inueniet eam ꝫ desidabūt mo
rtꝫ fugiet mors ab ipis. Et similitudi
nes locustarum similes equis paratis i prē
lium ꝫ suꝑ capita earum tanꝗm coronas

BEASTS IN FOCUS: THE APOCALYPSE

The book of Revelation, also called the Apocalypse, is the last book of the Bible, describing Saint John's vision of the events leading to the coming of Christ at the end of time. The visionary nature of the Apocalypse, with its detailed visual descriptions, makes the text ideal for illustration, and the medieval artists who translated its narrative originality into images helped make the illustrated Apocalypse one of the most distinctive and fantastic chapters in the history of medieval art. The images of this copy of the Apocalypse, done in a tinted drawing technique popular in Gothic England, impart unusual vividness to Saint John's account, and the manuscript's artist clearly gave free rein to his imagination in rendering the series of terrifying beasts that are portrayed as playing a prominent role in the end of the world.

Dyson Perrins Apocalypse

England, probably London, ca. 1255–60

JPGM, Ms. Ludwig III 1

78 ◁

The Fifth Trumpet: The Angel of Destruction and the Locusts, fol. 13v

The appearance of the locusts was like horses prepared for battle; and on their heads, as it were, crowns like gold, and their faces were like the faces of men. And they had hair like the hair of women, and their teeth were like the teeth of lions And they have tails like scorpions and stings; and in their tails is the power to hurt men for five months.

REVELATION 9:7–10

79 ▷

The Horsemen on Fire-Breathing Horses, fol. 14v

I saw in the vision the horses and those who sat on them: the riders had breastplates the color of fire and of hyacinth and of brimstone; and the heads of the horses are like the heads of lions; and out of their mouths proceed fire and smoke and brimstone . . . the power of the horses is in their mouths and in their tails; for their tails are like serpents and have heads; and with them they do harm.

REVELATION 9:17–19

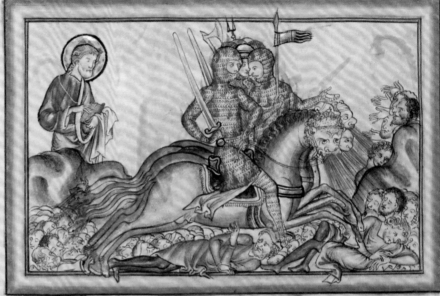

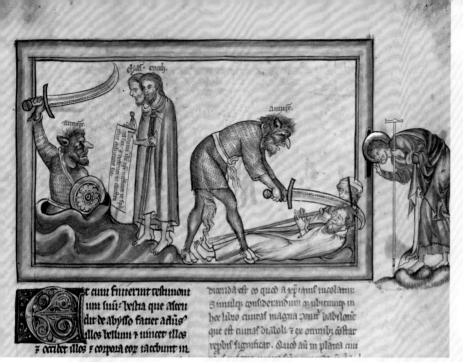

80 ◁

The Massacre of the Two Witnesses by the Beast, fol. 17

"I will grant authority to my two witnesses, and they will prophesy for twelve hundred and sixty days, clothed in sackcloth."... And when they have finished their testimony, the beast that comes up out of the abyss will make war with them, and overcome them and kill them.

REVELATION 11:3, 7

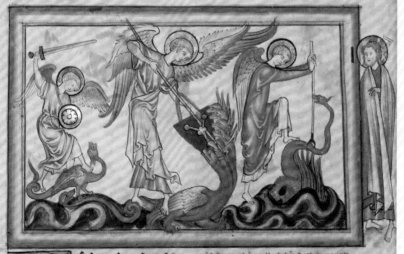

81 ◁

The Battle between the Angel and the Dragon, fol. 20v

And there was a war in heaven, Michael and his angels waging war with the dragon. And the dragon and his angels waged war, and they were not strong enough, and there was no longer a place for them in heaven. And the great dragon was thrown down, the serpent of old who is called the devil and Satan.

REVELATION 12:7–9

82 ▷

The Devil from the Earth, fol. 21

And I saw another beast coming up out of the earth; and he had two horns like a lamb, and he spoke as a dragon And he performs great signs, so that he even makes fire come down out of heaven to the earth in the presence of men. And he deceives those who dwell on the earth because of the signs which it was given to him to perform.

REVELATION 13:11, 13–14

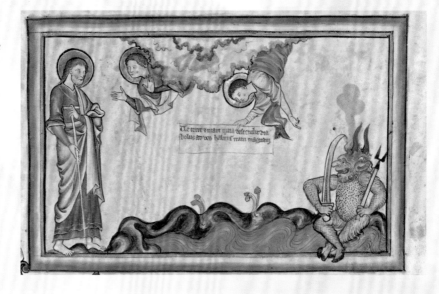

83 ▷

Unclean Spirits Issuing from the Mouths of the Dragon, the Beast, and the False Prophet, fol. 34v

I saw coming out of the mouth of the dragon and out of the mouth of the beast and out of the mouth of the false prophet, three unclean spirits like frogs; for they are spirits of demons, performing signs, which go out to the kings of the whole world, to gather them together for the war of the great day of God, Almighty.

REVELATION 16:13–14

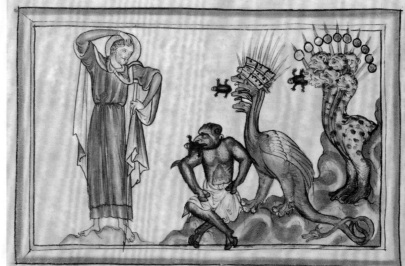

t uidt de ore dracouis ꞇ de ore bestie ꞇ de ore pseudo p plete spiritus tres immundos i modum ranaꝝ. Sunt eni spx demoniꝝ facientes signa. Et prodeut ad reges terre totius congregare illos i prelium ad diem magnum dei omni potentis. Ecce uenio sicut fur. Beatus qui uigilat ꞇ qui custodit uestimenta sua...

uniūsum ordem predicaturi sunt. Or hnum homines sunt futuri fine mundi ꞇ spx demo moꝝ uocante. q̃ demones in ipis habitaturi q̃ p ora coꝝ loquentur. Qui de ore antixpi ꞇ de ore pseudo ypeti et existe uisi sunt: qz p eoꝝ doc trinā filii diaboli efficiunt. Qui ꞇ de ore dra conis existe uisi sunt. qz p eos antixpi diabolus loquit. Ranis nichilom que sunt reptilia immu da ꞇ luto uiuenta recte assimilantur. qz si rane i sordidis agis q̃moꝛant tra ꞇ discipuli an...

SUGGESTIONS FOR FURTHER READING

Baxter, Ron. *Bestiaries and Their Users in the Middle Ages* (Sutton Publishing Limited, United Kingdom, 1998).

Bovey, Alixe. *Monsters and Grotesques in Medieval Manuscripts* (British Library, London, 2002).

Brise, Gabriel. *Medieval Hunting Scenes: "The Hunting Book" by Gaston Phoebus* (Miller Graphics, U.S.A., 1978).

George, Wilma, and Brunsdon Yapp. *The Naming of the Beasts: Natural History in the Medieval Bestiary* (Duckworth, London, 1991).

Hassig, Debra. *Medieval Bestiaries: Text, Image, Ideology* (Cambridge University Press, 1995).

Payne, Ann. *Medieval Beasts* (British Library, London, 1990).

Salisbury, Joyce. *The Beast Within: Animals in the Middle Ages* (Routledge, New York and London, 1994).

White, T. H. *The Book of Beasts* (G.P. Putnam's Sons, New York, 1954).

Online Resources

The Medieval Bestiary site, run by David Badke of Victoria, British Columbia, Canada: *www.bestiary.ca/index.html*

The Aberdeen Bestiary project, run by the University of Aberdeen: *www.abdn.ac.uk/bestiary/*

Digitized version of T. H. White's book (see entry at left) produced by the University of Wisconsin: *digicoll.library.wisc.edu/HistSciTech/subcollections/ BestiaryAbout.shtml*

BOOKS OF RELATED INTEREST FROM GETTY PUBLICATIONS
AND BRITISH LIBRARY PUBLICATIONS

Flemish Illuminated Manuscripts,
1400–1550
Scot McKendrick
160 pages
140 color illustrations
(British Library)

French Illuminated Manuscripts in
the J. Paul Getty Museum
Thomas Kren
144 pages
120 color illustrations
(J. Paul Getty Museum / British Library)

Illumination from Books of Hours
Janet Backhouse
160 pages
140 color illustrations
(British Library)

Italian Illuminated Manuscripts in
the J. Paul Getty Museum
Thomas Kren and Kurt Barstow
96 pages
80 color illustrations
(J. Paul Getty Museum)

A Masterpiece Reconstructed:
The Hours of Louis XII
Edited by Thomas Kren with Mark Evans
112 pages
77 color and 10 b/w illustrations
(J. Paul Getty Museum / British Library)

A Treasury of Hours:
Selections from Illuminated Prayer Books
Fanny Faÿ-Sallois
128 pages
55 color illustrations
(J. Paul Getty Museum)

Understanding Illuminated Manuscripts:
A Guide to Technical Terms
Michelle P. Brown
128 pages
64 color and 33 b/w illustrations
(J. Paul Getty Museum / British Library)

THE MEDIEVAL IMAGINATION SERIES

The Medieval Imagination series focuses on particular themes or subjects as represented in manuscript illuminations from the Middle Ages and early Renaissance. Drawing upon the collections of the J. Paul Getty Museum and the British Library, the series provides an accessible and delightful introduction to the imagination of the medieval world. Future volumes will cover fashion, portraiture, and marginalia, among other topics.

ABOUT THE AUTHOR

Elizabeth Morrison is Associate Curator in the Department of Manuscripts at the J. Paul Getty Museum. She is a specialist in French Gothic and Flemish Renaissance manuscript illumination, has curated numerous exhibitions at the Getty Museum, and was a contributor to *Illuminating the Renaissance* (2003) and *Flemish Manuscript Painting in Context* (2006).

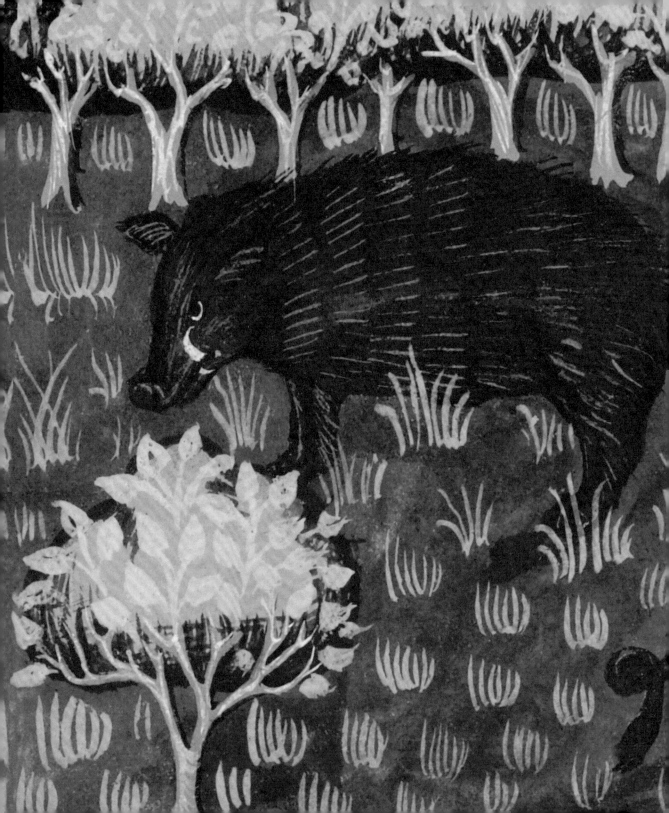